To my number 1 Beauty Queen!
Hope you have the most amazing
my darling.
All my lov
Violet

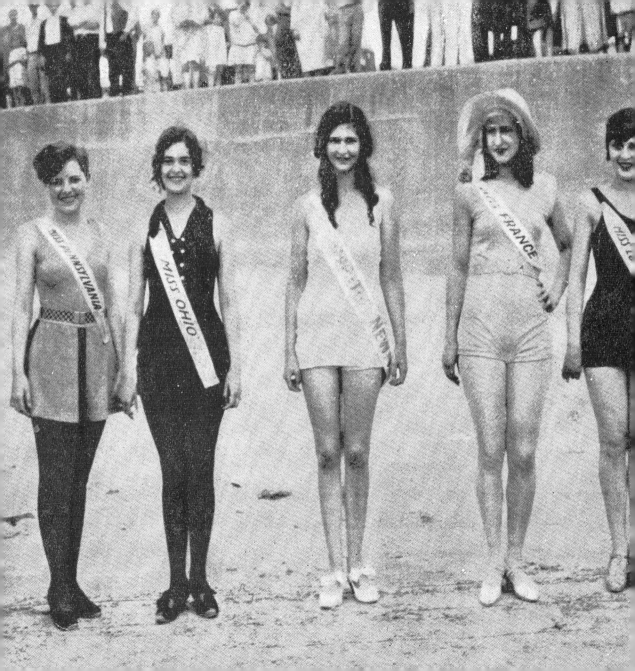

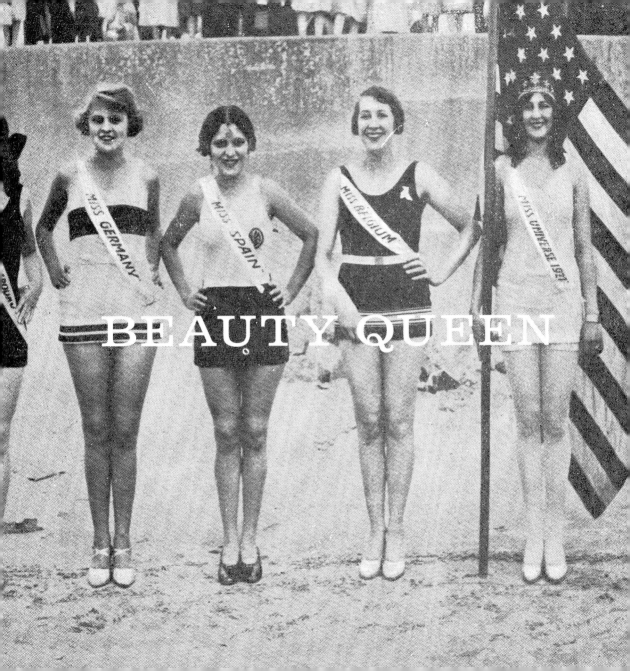

BEAUTY QUEEN

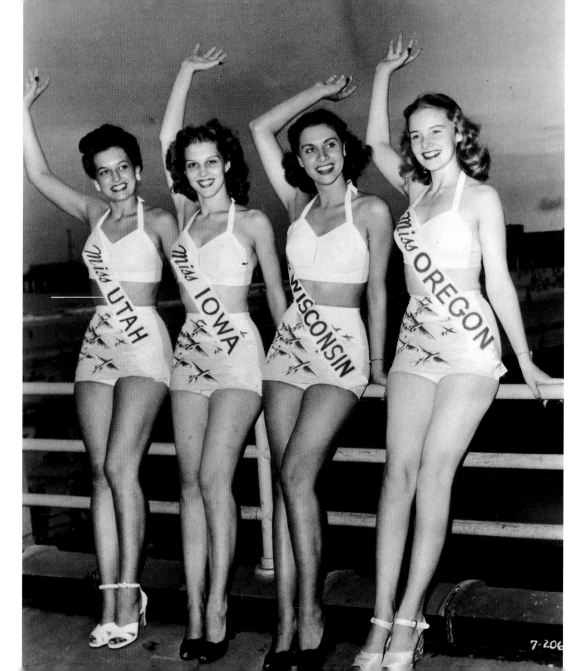

HERE SHE COMES . . .

BEAUTY QUEEN

by Elissa Stein

FOREWORD BY
LEE MERIWETHER

CHRONICLE BOOKS
SAN FRANCISCO

Library of Congress Cataloging-in-Publication Data:

Stein, Elissa.

Beauty queen : here she comes— / by Elissa Stein.

p. cm. ISBN 0-8118-4864-7 1. Beauty contests. I. Title.

HQ1219.S758 2006 394'.5—dc22 2005007495

Manufactured in China.

Designed and typeset by Benjamin Shaykin.

Distributed in Canada by Raincoast Books, 9050 Shaughnessy Street, Vancouver, British Columbia V6P 6E5

10 9 8 7 6 5 4 3 2 1

Chronicle Books LLC, 85 Second Street, San Francisco, California 94105

www.chroniclebooks.com

View-Master is a registered trademark of Fisher-Price and its parent company, Mattel, Inc.

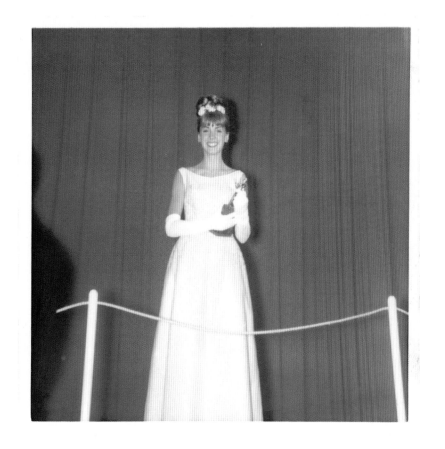

Say to yourself, "I'm beautiful, I'm bubbly, I'm marvelous,"
and pretty soon you will be. —JACQUE MERCER

For Jackson, Isabel, Emma, Hayden, Kyra,
Samira, and Chaya and their beautiful, magical dreams.

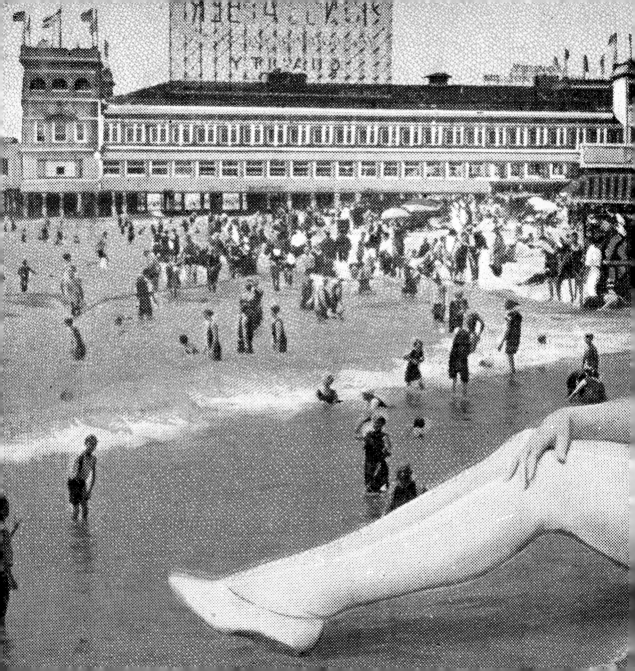

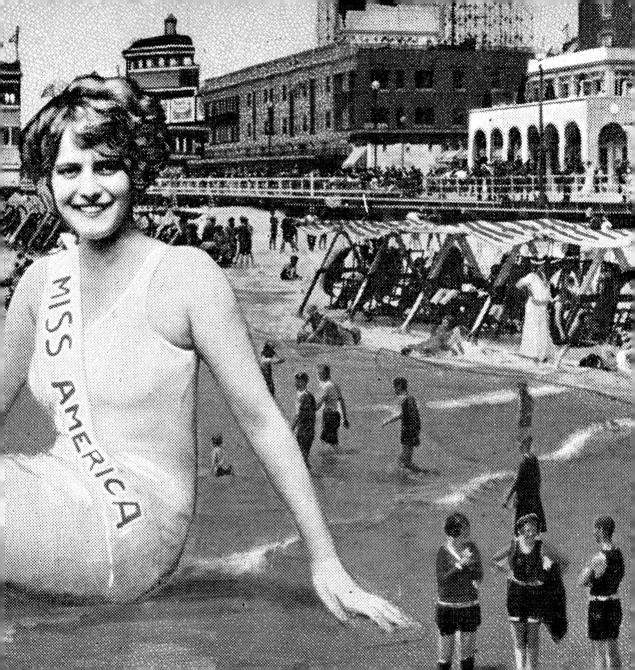

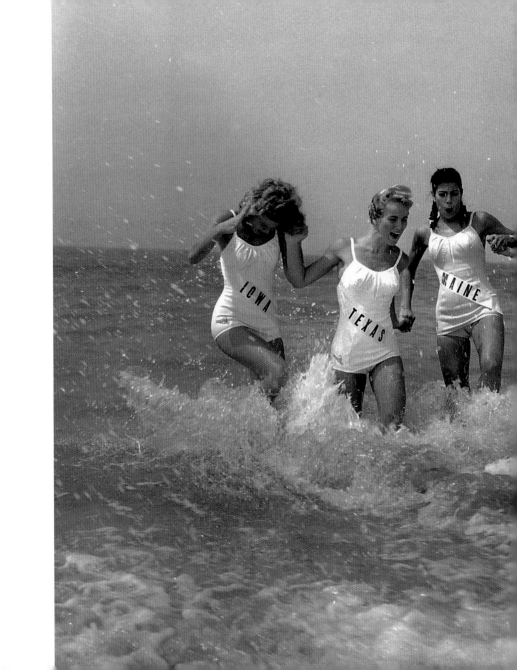

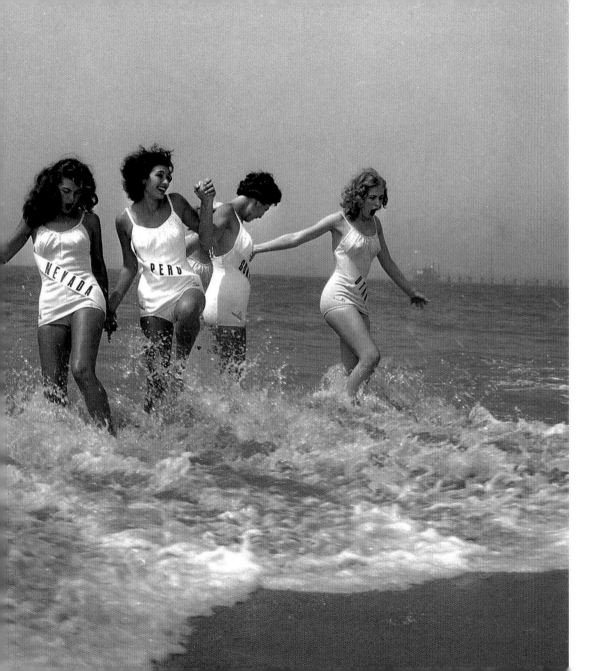

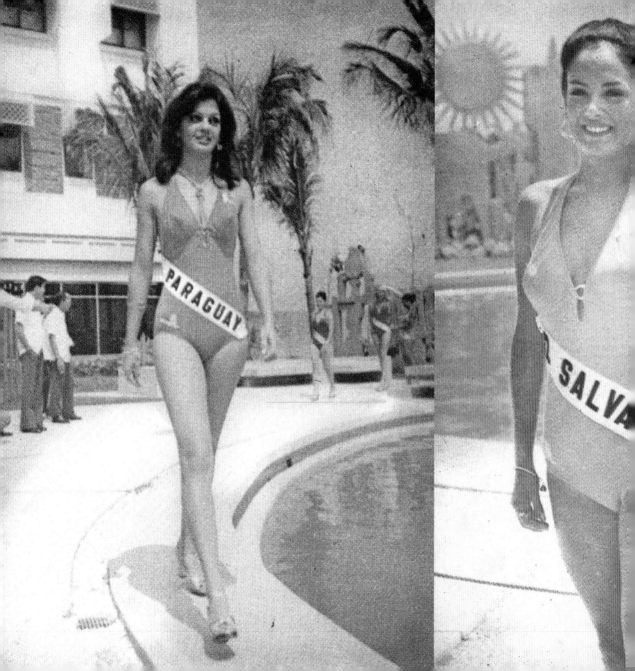

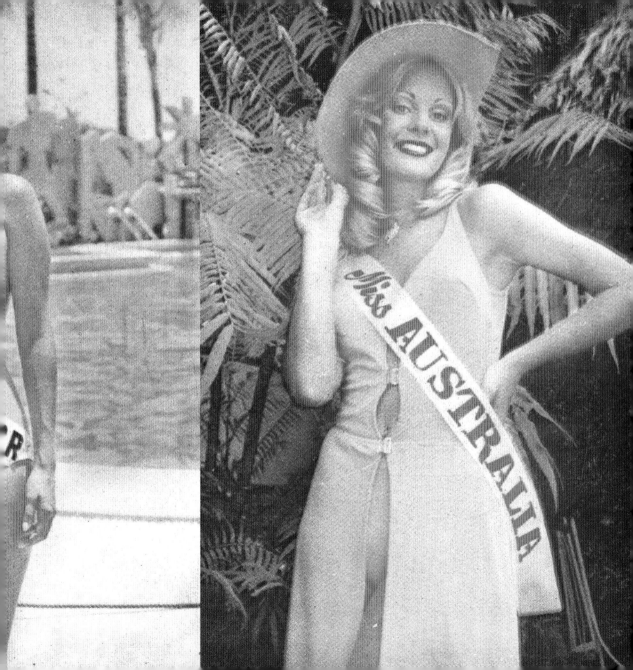

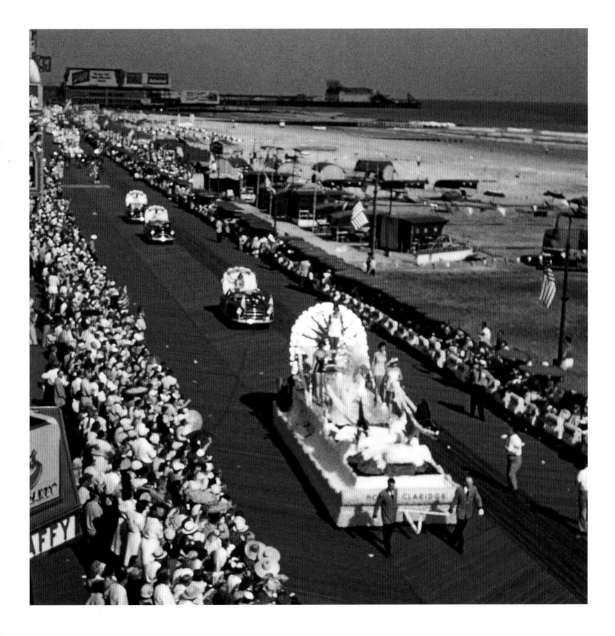

Contents

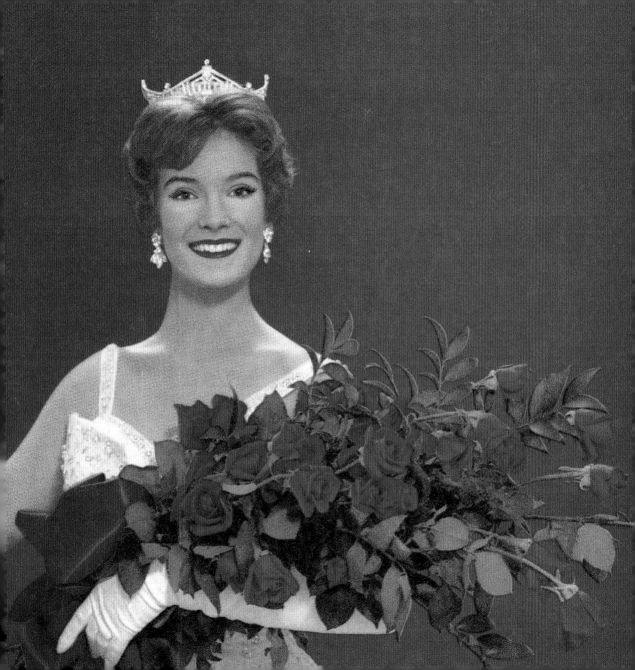

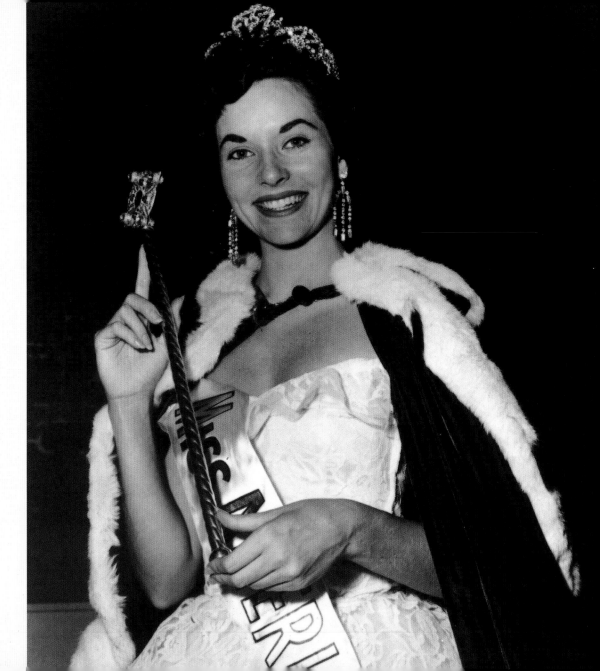

FOREWORD

When Evelyn Ay Sempier, Miss America 1954, completed her year's reign and placed the crown on my head, my world changed in an instant. I'm not alone—literally thousands of young women have undergone this unique transformation.

Elissa Stein has done an incredible job in researching all of these local, state, and national pageants. What a delight to read the history and feast on the fabulous (and sometimes hysterical) photos! Thanks, Elissa, for capturing this tradition with such style and grace. Enjoy!

— *Lee Meriwether*

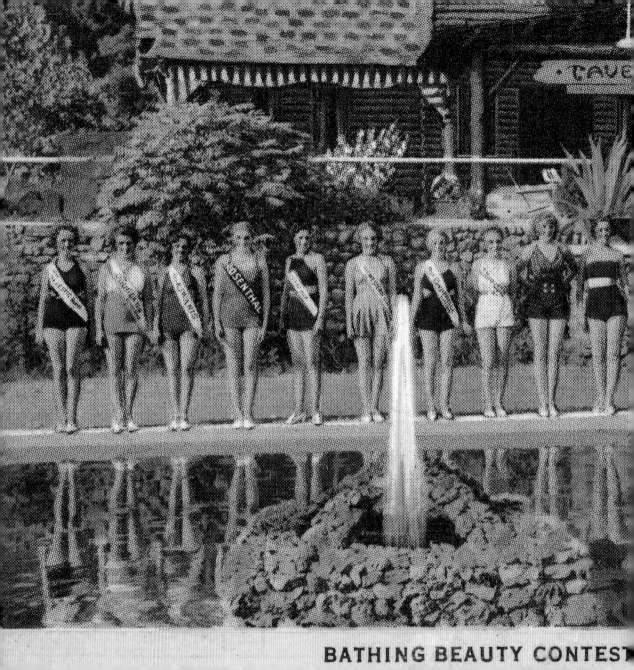

BATHING BEAUTY CONTEST

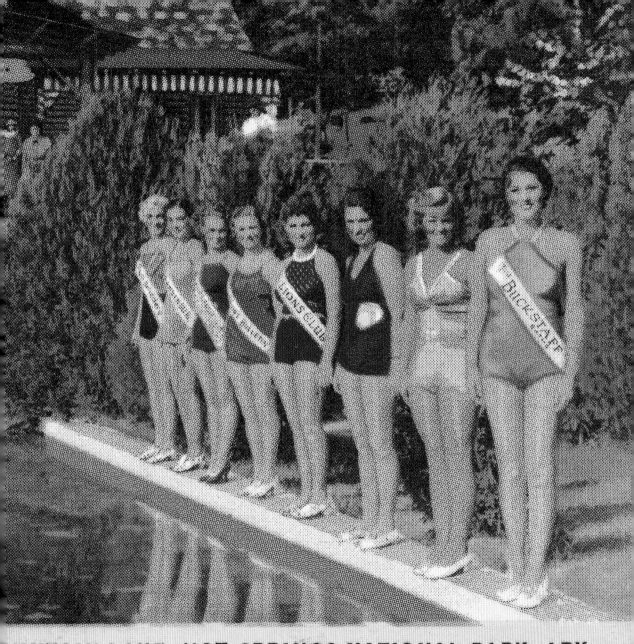

OUNTAIN LAKE, HOT SPRINGS NATIONAL PARK, ARK.

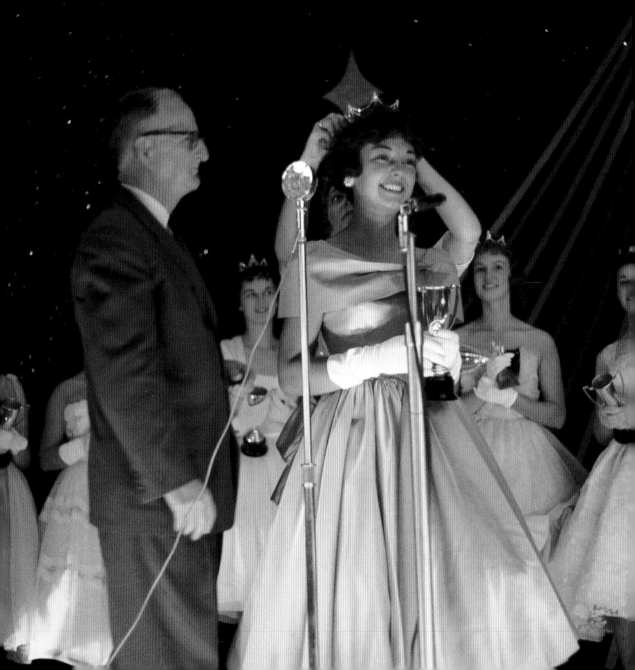

Introduction

Smiles frozen in place, hearts pounding under their glittering gowns, the final five contestants stand center stage. The master of ceremonies continues his jolly banter, drawing out the suspense as he prepares to open the envelope and announce the name of the new beauty queen. Following a dramatic pause he says, "The fourth runner-up is . . ." and with that, one girl's dream is over. Still smiling, but slightly less brightly, the remaining four clutch each other's hands tightly—each one praying her name won't be called next. Third runner-up, second runner-up. We're riveted. Two girls are left. Only one crown. "The first runner-up is . . ." and with that we know the winner. The music swells and tears stream down her face as a tiara is hastily pinned to her hair. Clutching a bouquet, she waves to her fans as she takes that first glorious walk down the runway. It's the moment she's always dreamt of. It's the moment contestants across the globe and throughout the decades dream of. And for her, the dream has come true.

With that win come many, many perks. Today's beauty queens are showered with fabulous prizes during their reign: they travel the world, meet dignitaries and heads of state, and get priceless media exposure. This royal treatment is a far cry from that of the first beauty queens, many of whom were crowned at the beach and then went home to relative anonymity. Unlike today's glitzy affairs,

those first pageants made for an afternoon's simple entertainment. Invented by local businessmen as a way to extend the summer resort season, these beachside pageants kept folks entertained and gave girls a chance to shine in the spotlight. In slightly risqué bathing costumes, on a stage in front of hundreds of beachgoers, these young women clamored for a chance to win the title—like Beauty Queen of the Universe or Miss Bathing Girl Review—even if for only that day.

From those early beachside contests, the beauty pageant industry has evolved into a multimillion-dollar business, with tens of thousands competing, worldwide, every year. Even more people work in the industry, from consultants to choreographers, pageant organizers to television executives, and each has a role in pulling together a riveting show.

When they do their job well, we can't turn the spectacle off. For those of us in the audience, it's an evening of entertainment at its lightest and breeziest—beautiful girls, fabulous fashion, musical numbers, lighthearted banter, and a dramatic finish. But we see only the finale of a long, long journey. Many contestants compete for years, practicing and honing their pageant skills. Winning the crown takes a full-time commitment. It's not just about looking good in a bathing suit and heels. Instead, it's about perseverance, congeniality, and a tremendous dose of self-confidence. Not to mention glamour, beauty, and poise!

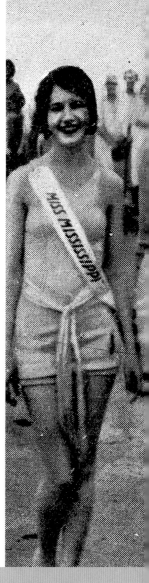

No matter what sort of pageant, the outcome is the same—

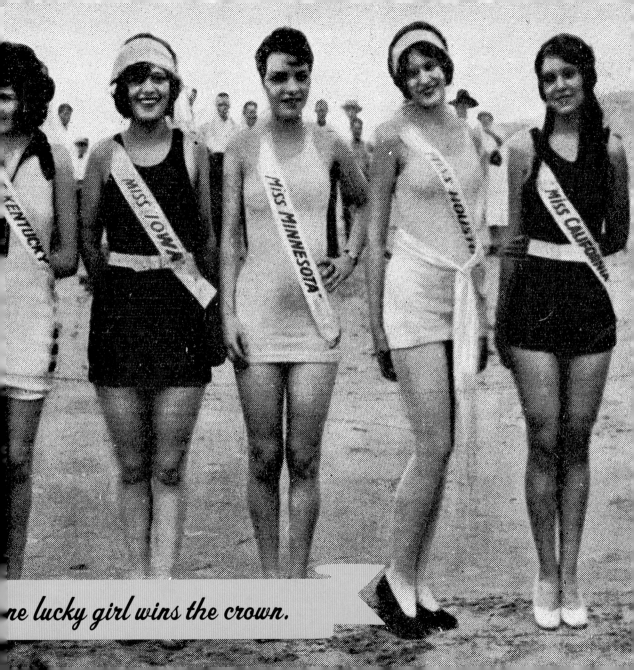

ne lucky girl wins the crown.

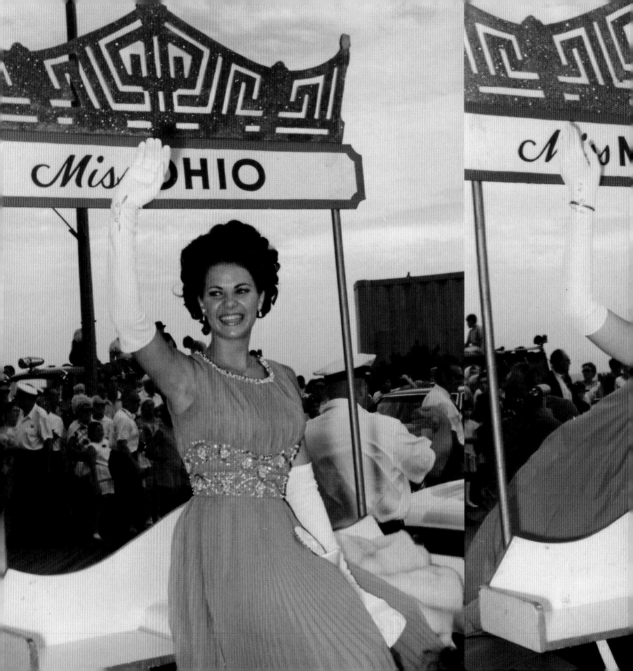

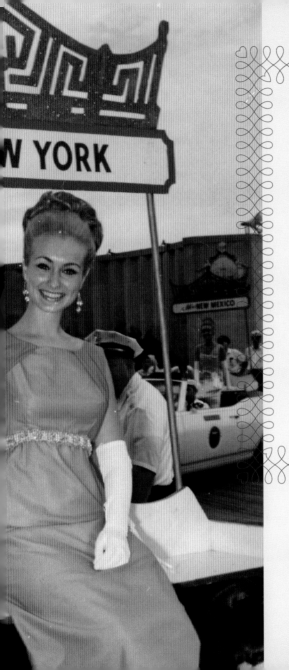

THE BEAUTY QUEEN WAVE

Majestic, elegant, commanding, the beauty queen wave lets people know you're royalty. Extend your arm out to the side, and bend your elbow to 90 degrees. Your fingers to your elbow should form one vertical line. Slightly cup your hand. Without moving your fingers or wrist, rotate your hand from the forearm. As you wave, slowly turn your head from side to side, making eye contact with your admirers. And, most important, let a smile light up your face.

The beauty queen wave works best when you're walking down the runway, standing in front of an admiring crowd, or participating in a parade.

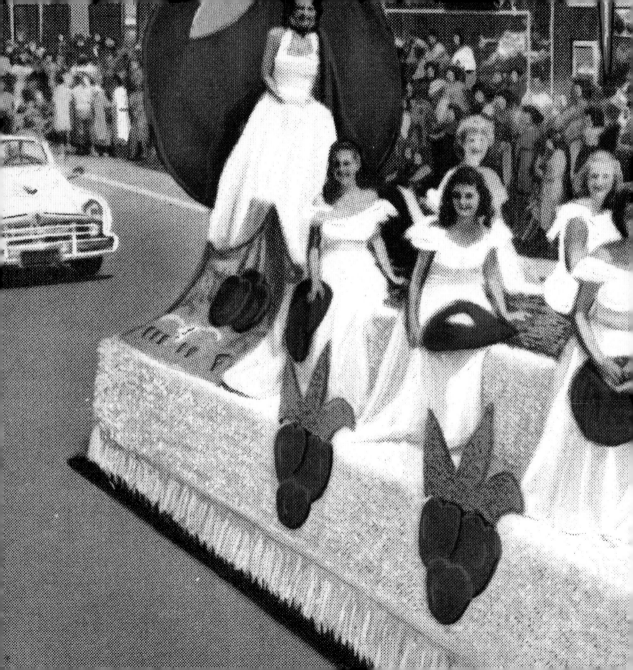

Miss HISTORY

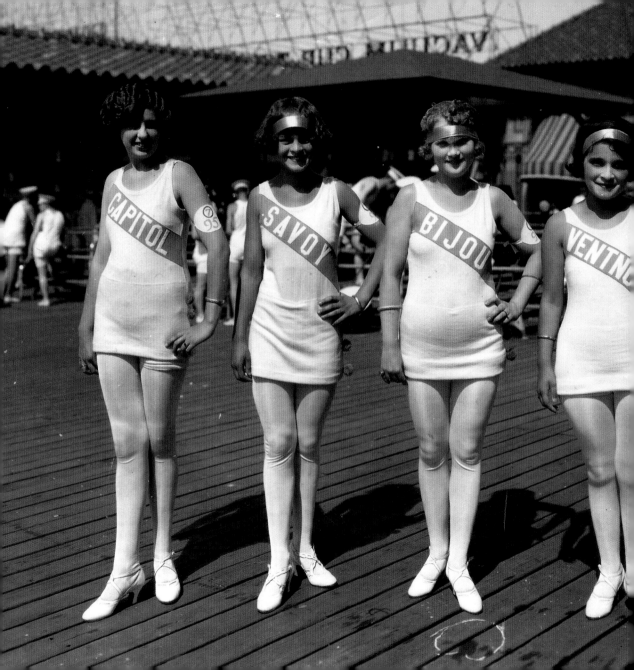

For most of us, the words "beauty pageant" conjure up images of a handsome master of ceremonies, beautiful girls in glamorous gowns, swimsuits and high heels, and choreographed dance numbers. But today's events are a far cry from beauty contests of old. The first beauty pageants were local beachside publicity stunts. It took a few years for them to catch on, but once they did, they quickly became entrenched in our pop culture landscape. Whether a beauty queen is crowned on a boardwalk or in front of a television audience, we have always been fascinated, tuning in year after year to share in the pageantry, the drama, and the excitement.

Rehoboth Beach, a seaside resort town in Delaware, hosted the first documented beauty pageant in 1880. The judges were looking for Miss United States, "the most beautiful unmarried woman in our nation." After a week of being judged on face, figure, hands, feet, hair, poise, grace, and costume, Myrtle Meriwether won the crown in front of an ecstatic crowd. Although this first Miss United States pageant proved to be great entertainment, it wasn't successful enough to warrant another contest the next year.

Part of the problem lay in the social mores of the day. Most upstanding citizens didn't altogether approve of young girls in bathing costumes competing on stage. It just wasn't seemly. However,

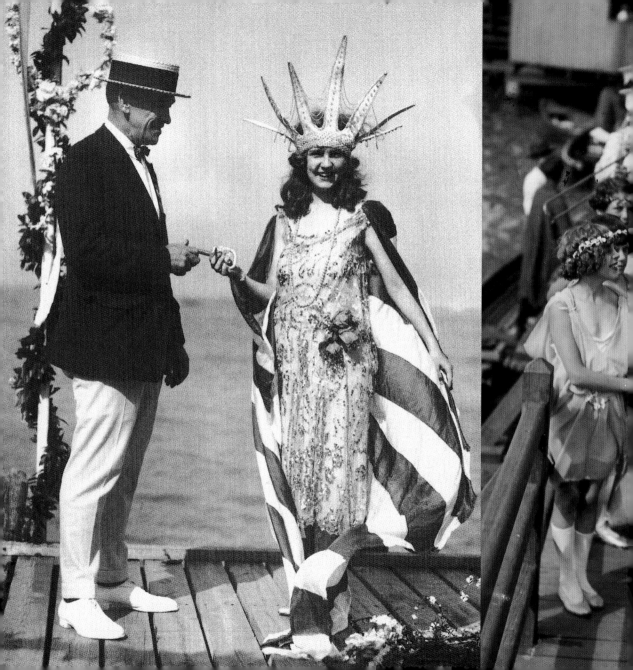

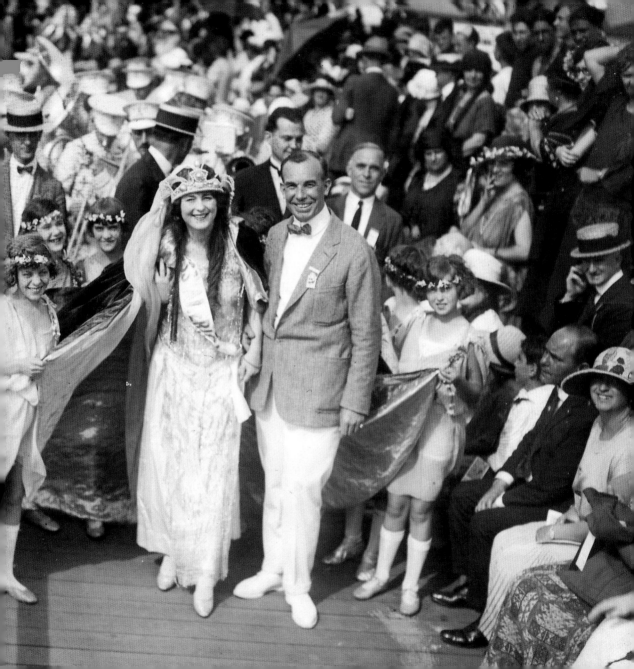

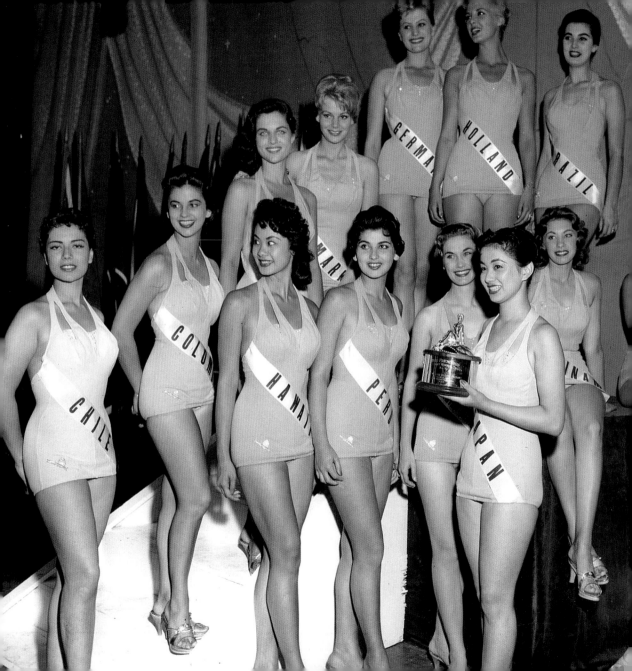

formal photographs of beautiful young ladies appearing in local newspapers' competitions was another matter entirely—and society wholeheartedly approved. As the practice of featuring lovely women gained in popularity, newspapermen began publishing more of these photos of pretty young ladies as a ploy to increase circulation and expand readership. Thousands of young girls clamored to have their portraits featured. From here, the fad went a step further, and prizes were awarded to those young ladies who best conformed to an old-fashioned, artifice-free, all-natural ideal.

Women who cherished marriage and motherhood above all else won the contests.

It's interesting to note that at this time the burgeoning suffrag-ettes' movement was taking hold. But while women were marching the streets for the right to vote, the media chose to reward conserva-tive values.

Meanwhile, baby beauty pageants also enjoyed enormous popu-larity during the end of the 1800s. Parents would parade their cherubic infants, dressed in Sunday finest, past adoring crowds. As infants peered out of their carriages, judges rated their good breeding and cheerful dispositions. Held at many Northeastern seaside resorts, these annual baby parades and contests remained wildly popular for decades.

But as the women's rights movement gained momentum and restrictive fashion became a thing of the past, beauty pageants really took the beaches by storm. In 1920, in an attempt to extend their

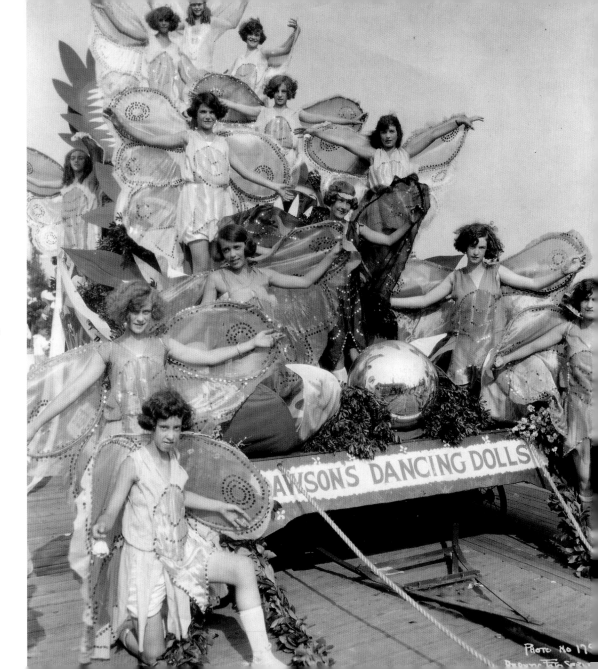

36

lucrative summer season, Atlantic City businessmen introduced the Fall Frolic, a weekend of fun and entertainment culminating in a tremendous rolling chair parade. Rolling chairs, all the rage on boardwalks up and down the eastern coast, were canopied benches on wheels pushed by young men. The Atlantic City parade featured 350 rolling chairs, each graced with a lovely maiden waving enthusiastically to the crowd. The festival's founders had a modest success on their hands, but they saw a way to reap even more publicity and attention. With the approval of Sam Leeds, president of Atlantic City's chamber of commerce, 1921's Fall Frolic extended into a full-fledged extravaganza, ending with a beauty contest. Up and down the East Coast, newspapers solicited local entries. Each paper's winner then traveled to Atlantic City to compete for the title of Inter-City Beauty. The lovely sixteen-year-old Margaret Gorman, one of eight contestants and a favorite of both the judges and the crowd, stole the show. Because of the popularity of the Inter-City Beauty contest, its contestants were invited to participate the next night in the Bather's Review, competing for the title of the Most Beautiful Bathing Girl in America. Margaret won both the title and the accompanying Golden Mermaid trophy. She came back the next year to defend her title. After her second win, Herb Test, an Atlantic City reporter, referred to her as "*Miss America*" and a tradition was born.

But even though beauty pageants grew in popularity during the 1920s, conservative groups objected to them, just as they had from the start. These groups considered beauty contests risqué, believing that they attracted contestants with loose morals. The Pulchritude of Beauty, an immensely popular contest started in 1920 in Galveston,

Texas, screeched to a halt in 1932. And the Miss America pageant, despite its widespread acceptance, fizzled out after the 1927 contest. Pageant organizers tried valiantly to bring the event back. But even with their sporadic successes, Miss America lay in limbo until 1935, when Lenora Slaughter came on board and revamped the pageant's image into one of respectability, helping Miss America become the ultimate celebration of the girl next door—*the one every girl wanted to be and every boy wanted to marry*.

The Miss America pageant's following grew every year. Each queen's crowning became front-page news; newsreels of the coronation ceremonies were shown in movie theaters across the country, turning thousands of young, starry-eyed girls into potential contestants. Local pageants blossomed in small rural towns and heavily populated urban centers, providing more and more girls a chance to pursue a crown and the dream of a glamorous new life. Throughout, Miss America remained an icon of virtue, innocence, and patriotism. In fact, during World War II, when many thought beauty pageants to be inappropriate given the sobriety of the times, Miss America came to symbolize hope and home to American soldiers. During the war years, reigning Miss Americas even visited the troops and sold war bonds, securing a place for the beauty queen as a revered national figure and role model. And with the addition of scholarship funds to the prize, the pageant became a way for women to further their education.

But the contest's sovereignty as the largest, most popular pageant soon came to an end. In 1950, the newly crowned Miss America, Yolande Betbeze, announced she would not spend her reign appearing

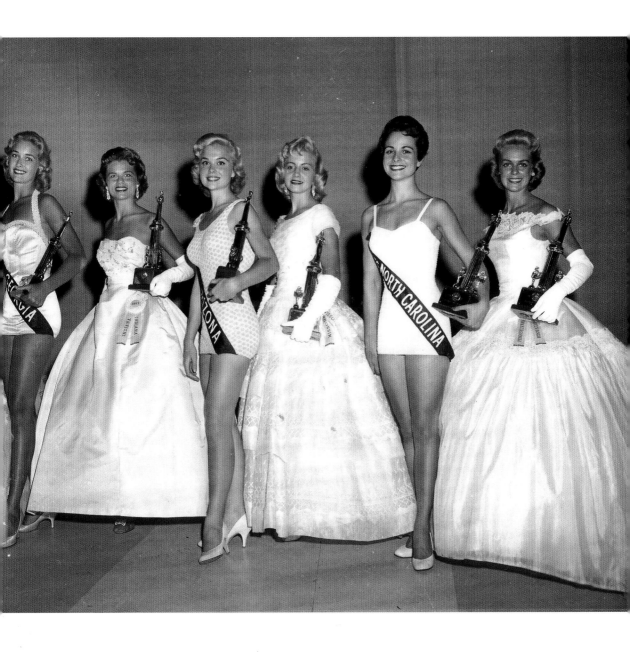

ROYAL TREATMENT

Throughout history, tiaras have symbolized royalty, nobility, or great achievement. In ancient Egypt, princesses wore delicately fashioned tiaras, while ancient Greeks rewarded their athletes with wreaths of laurel leaves to wear on their heads. Ancient Romans used simple headpieces to denote citizens of rank and honor. Monarchs across Europe continued the tradition—a tiara or crown is standard attire for kings and queens.

Given the tiara's regal history, it's no wonder beauty pageants adopted this tradition. When the winner of a pageant is announced, she becomes "queen" and is ceremoniously crowned with a glittery tiara. While no longer in vogue, a scepter and a luxurious cape carried by a young page were also bestowed on pageant winners in decades past. Then, clad in her regal finery, she would pose for photos on a throne, with her court (her runners-up) surrounding her.

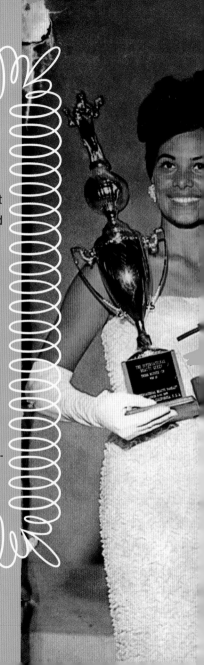

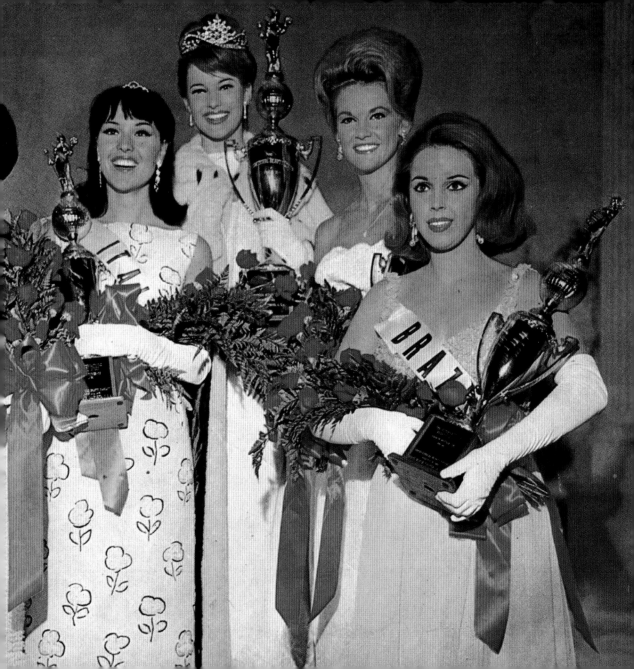

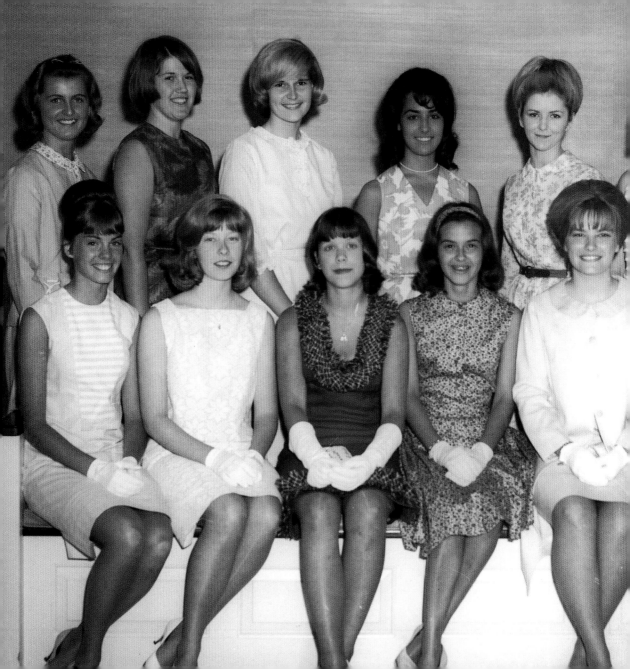

in a swimsuit, as previous title winners had. Executives at Catalina, the bathing suit manufacturer and a major sponsor, were furious. So when Jacque Mercer, Miss America 1949, suggested to E. B. Stewart, Catalina's CEO, that he start his own beauty contest, he did just that. The first Miss United Nations Pageant, soon to be known as Miss Universe, was held in Long Beach, California, in 1952. That pageant was actually two competitions—the Miss USA contest and its sister competition, Miss Universe. Originally, both competitions took place in the same week, but the schedule grew too hectic and the pageants split in 1965. Miss USA is now held about six weeks before Miss Universe, with each pageant traveling to a new host city each year. The exotic locations and elaborate production numbers help make Miss USA and Miss Universe two of the most-watched pageants in the world today.

Not just a phenomenon in the United States, beauty pageants became tremendously popular all over the globe in the 1950s. Miss World, now a fixture on the international pageant scene, began in 1951, as British businessman Eric Baker looked for a way to participate in the Festival of Britain, a major London event. He organized a contest featuring the most beautiful women in the world. He called it the Festival Bikini Contest, but the media dubbed the winner "Miss World."

With the advent of television, the world of beauty pageants opened up to viewers all over the planet. In 1954 Miss America was televised for the very first time. As a sobbing Lee Meriwether won the crown, an audience of 27 million people watched and were hooked—the entire country could now share the drama and glory. Live. Radiant girls in debutante gowns charmed families as they

watched Bert Parks singing "There She Is, Miss America." For many years, the Miss America pageant remained one of the highest-rated shows on television.

In the late 1960s, as the world underwent major social changes, pageants stayed remarkably the same. Older generations found comfort in the anachronistic swimsuits and hairstyles and old-fashioned talent competitions. But to younger people, Miss America represented much of what was wrong at the time. Few contestants from minority groups competed, and the ideals that beauty pageants espoused were antithetical to the growing women's rights movement. In 1968, the Women's Liberation Front held a protest on the boardwalk during the Miss America telecast. That same night, Atlantic City hosted the first Miss Black America Pageant. Its organizers, the National Association for the Advancement of Colored People, started the pageant very late in the evening, hoping the media would stop by to cover their event after Miss America was crowned. The NAACP and the contest's newly crowned queen, Saundra Williams, had two objectives—to protest the absence of black women in Miss America competitions, and to promote an alternative beauty ideal to the millions of young women who didn't fit the typical beauty queen mold. The Miss Black America pageant was the forerunner of events celebrating every type of beauty—from Miss Ebony to the Cherry Blossom Queen (Japanese American women), Mrs. America (married contestants) to Miss Islander (women from the Caribbean).

Then, in 1970, Cheryl Browne won the Miss Iowa title, becoming the first black woman to compete in the Miss America pageant. Her victory opened the door for more minorities to participate in,

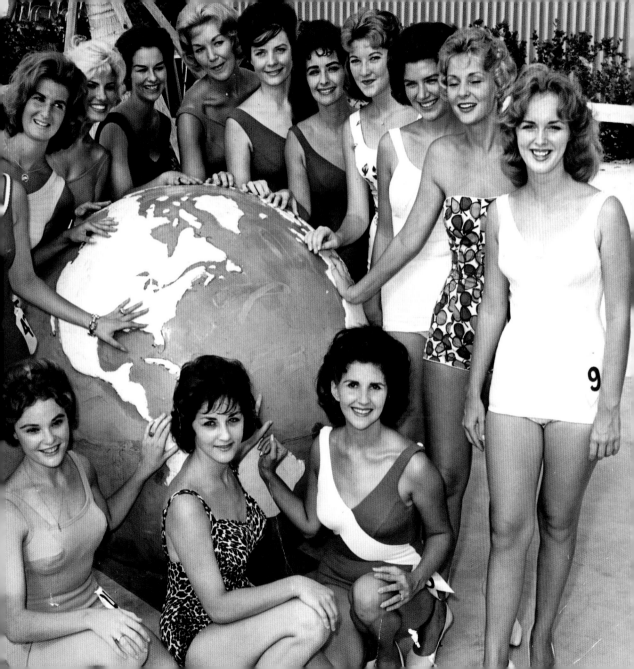

THE GODMOTHER OF MISS AMERICA

In 1935, as pageant organizers were working feverishly to bring the defunct Miss America pageant back to life, they realized that they needed help pulling it off. So they asked Lenora Slaughter, a remarkable marketer for the St. Petersburg, Florida, chamber of commerce, to run the 1935 pageant. Initially hired for six weeks, she ended up staying in Atlantic City as pageant director until her retirement in 1967. During her term of service, she not only revitalized the Miss America pageant but also introduced competition standards that set the bar for pageants today.

Lenora aimed to create a pageant of respectability, one that parents would feel comfortable sending their daughters off to compete in. She gained the support of upstanding Atlantic City businesses and persuaded local society matrons to serve as both chaperones and hostesses. She set strict rules—contestants had to be between the ages of eighteen and twenty-eight, and they must never have been married (thus keeping the "miss" in the title legitimate). They had to represent a geographical region, not a commercial interest. And

while in Atlantic City to compete, contestants were forbidden to go to nightclubs or bars and could never be seen smoking.

Lenora Slaughter also introduced two revolutionary new aspects to the Miss America pageant—the talent competition and scholarship funds. She saw the pageant as more than a beauty contest—it could provide a chance for talented, intelligent women to further their opportunities. In 1938 she instated talent as a mandatory portion of the competition. And in 1945, Lenora pulled together $5,000 from corporate sponsors to create the first-ever Miss America scholarship fund. That year's lucky winner was Bess Myerson, the first Miss America who was already a college graduate, and the only Jewish woman to win the title in the pageant's entire history. And in subsequent years Lenora made good on her promise that all state title holders participating in Atlantic City would receive scholarship funds.

During this era, as Miss America's image gained propriety, Lenora proclaimed that Miss America would be crowned in an evening gown—all previous

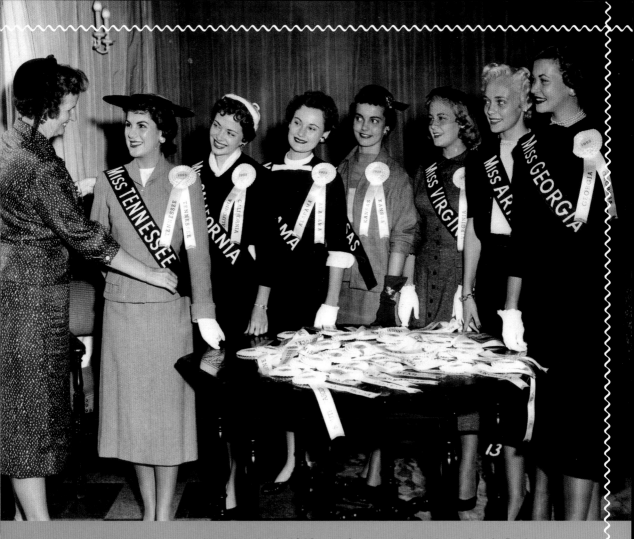

winners were crowned in swimsuits. In 1948, just before the emcee announced Bebe Shopp as the winner, reporters threatened to leave, saying it wasn't worth taking a photo of a queen without her swimsuit. But Lenora stood her ground, and from then on contestants have worn tiaras and evening gowns for their coronation attire.

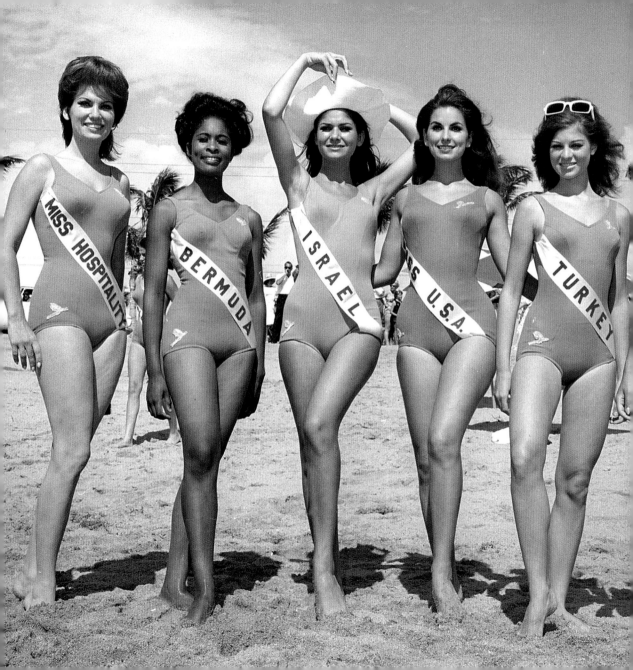

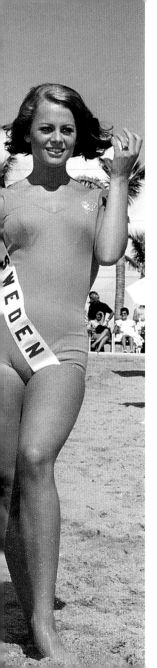

and win, beauty pageants. In 1977, Janelle Commissiong of Trinidad-Tobago was the first black woman to win the Miss Universe title and, in 1983, Vanessa Williams broke the color barrier and won the title at the Miss America pageant. Although she had to relinquish her crown due to controversial photos that surfaced later that year, her win remains a groundbreaking moment in pageant history. The first runner-up, Suzette Charles, assumed the title and became the second black woman to be crowned Miss America.

Even as beauty pageants accepted women of every ethnic background, their concept became increasingly difficult for many to accept. People felt the contests denigrated women by rewarding them solely for superficial beauty. In response to changing times, pageant organizers added a platform of social activism to their requirements. Starting in the late 1980s, contestants were required to support a cause—spending time volunteering for and speaking out on its behalf, all while working their way through the pageant system. A reigning queen now spends most of her year promoting her platform. Her title comes with media exposure and endless opportunities to educate the public regarding her chosen cause.

From those early days at the beach, beauty pageants have evolved into a multimillion-dollar industry, attracting thousands of contestants and millions of fans. And while often steeped in contro-versy, pageants have never been more popular. Around the globe we continue to tune in and watch, still fascinated after all these years, and happy to share the dream as one lucky girl pins on her tiara, clutches her roses, and waves to us from the runway.

51

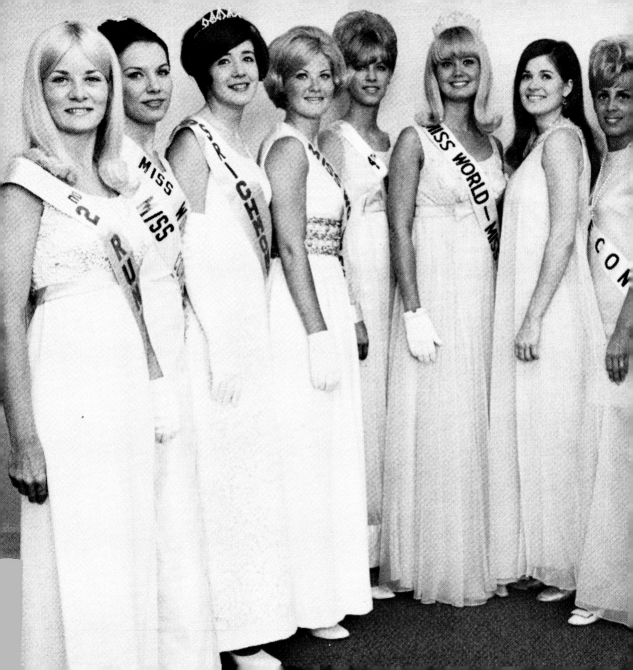

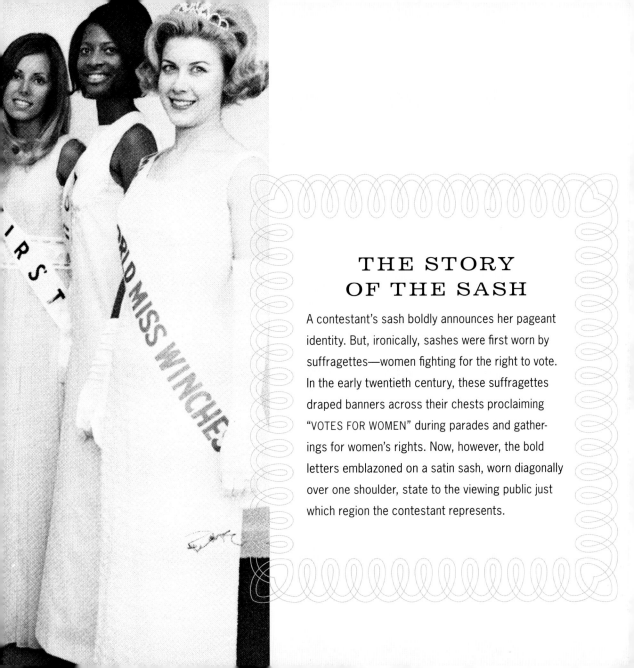

THE STORY OF THE SASH

A contestant's sash boldly announces her pageant identity. But, ironically, sashes were first worn by suffragettes—women fighting for the right to vote. In the early twentieth century, these suffragettes draped banners across their chests proclaiming "VOTES FOR WOMEN" during parades and gatherings for women's rights. Now, however, the bold letters emblazoned on a satin sash, worn diagonally over one shoulder, state to the viewing public just which region the contestant represents.

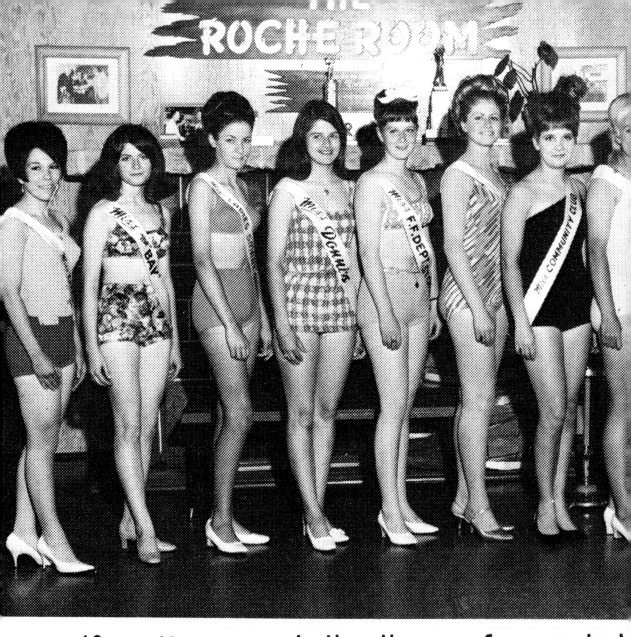

16 pretty young ladies line up for pre-jud

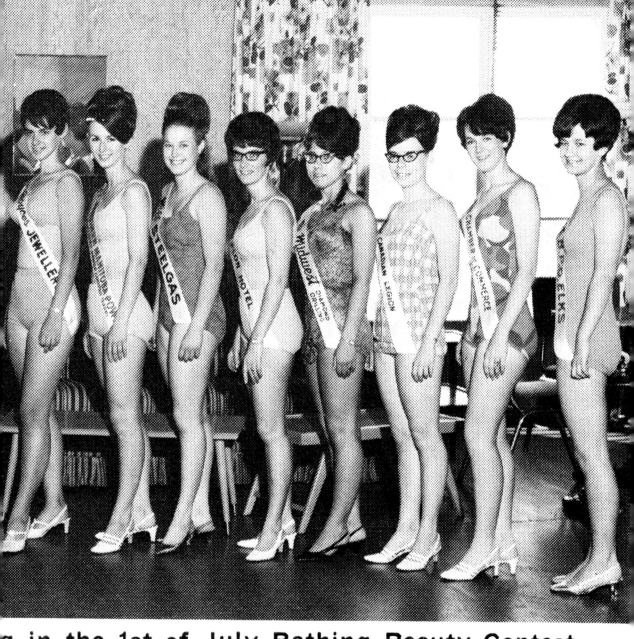

g in the 1st of July Bathing Beauty Contest.

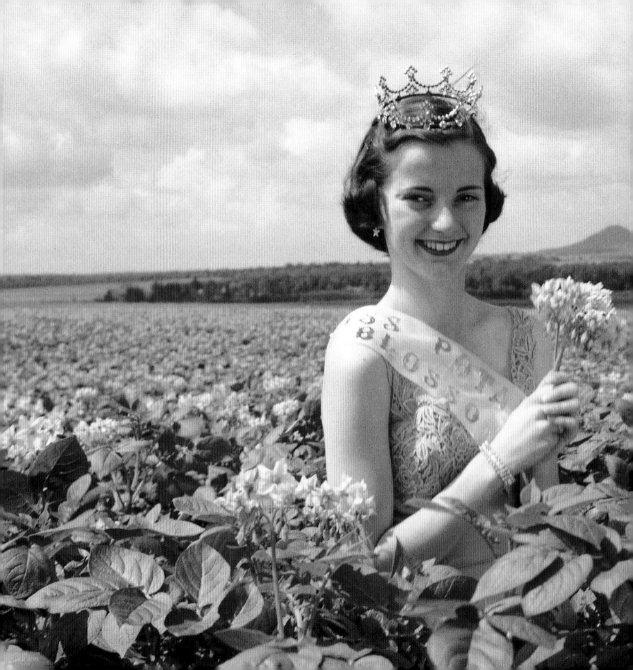

FESTIVAL QUEENS

Along with conventional pageants, a wide variety of festivals and functions crown a queen to add a dash of pomp to their events. In events crowning queens of every possible sort—home-coming queens; college-football bowl queens; queens of festivals celebrating cherry blossoms, sweet potatoes, wild blueberries, and peanuts; queens of parades and charity events—local girls of all stripes enter these contests for a bit of glamour and glory. Less com-petitive than a beauty pageant, and not requiring swimsuit, evening gown, or talent competition, many of these events select a girl based on her poise, personality, and good looks.

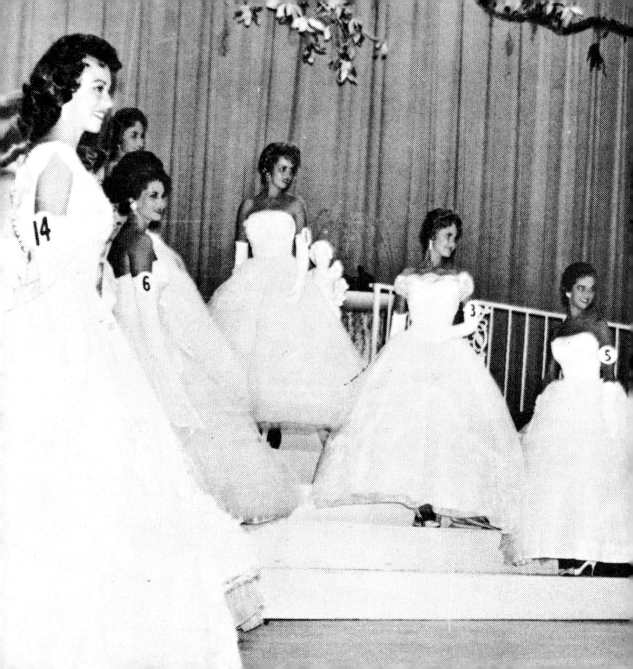

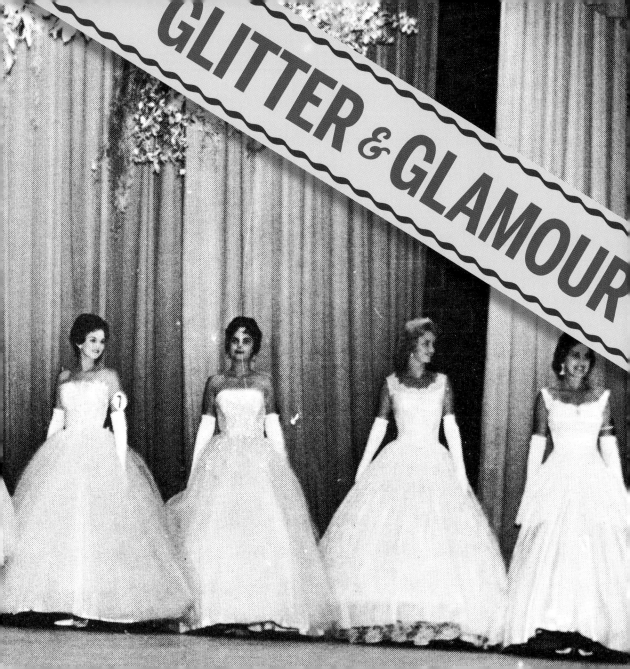

GLITTER & GLAMOUR

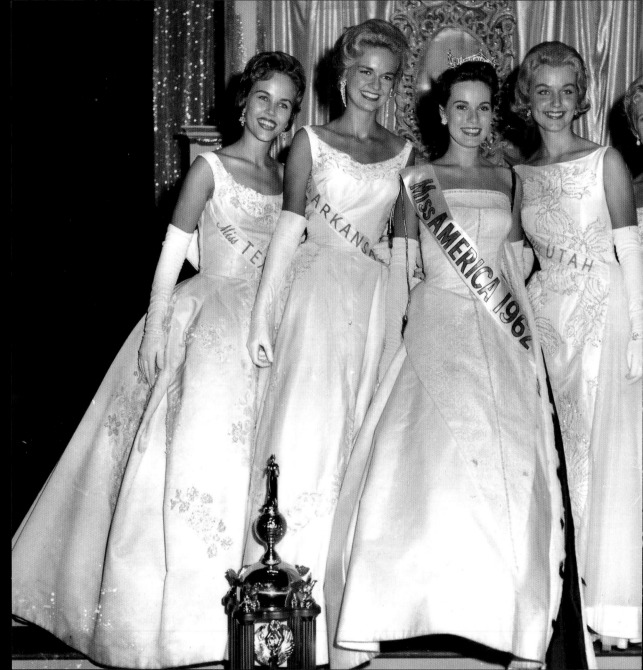

A beauty queen is always the epitome of tasteful glamour. She'd never wear anything shocking. And certainly nothing too revealing. A beauty queen projects a wholesome, clean-cut image—she is the girl next door who just happens to wear an evening gown with ease and can make a bathing suit with high heels look as natural as a day at the beach. In all of her wardrobe choices, she creates an upstanding and elegant look, worthy of her title and the responsibility it carries.

When we envision a beauty queen, we most likely see a glowing girl in her glamorous gown, with upswept hair and long gloves. But wearing formal evening gowns at the crowning moment of a pageant is a relatively recent tradition. From the beginning, the bathing suit competition played the most important role in determining the queen. As soon as the 1920s ushered in shorter, tighter bathing costumes—a far cry from the bulky, long-skirted, wool (yes, wool) swimsuits of old—formal bathing-beauty contests sprang up as lighthearted forms of entertainment.

While the bathing suit competition continues to be a pageant highlight today, it's always been met with some consternation. Early pageant organizers, who sought out contestants with a wholesome appeal, struggled to maintain a sense of decorum in the face of changing fashions and social mores.

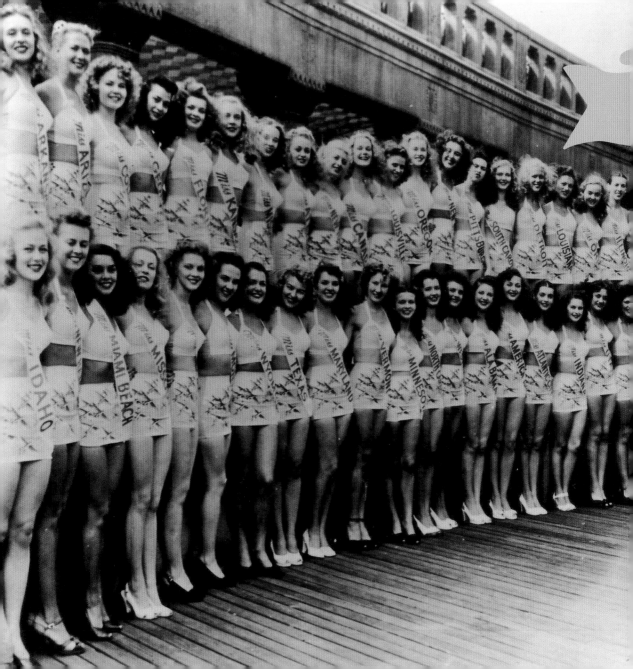

So, in the 1940s, pageant organizers established strict rules governing how revealing suits could be. Organizers banned two-piece suits altogether, and the ultraconservative panel suit became the designated wear. This style sat ultra-low on the thigh, with a panel running across the front that covered the tops of the legs. The Miss America pageant required contestants to wear this style of suit until 1970, regardless of evolving (and shrinking) swimsuit fashions. And while today's pageants allow swimsuit styles more closely mirroring those worn on the beach, officials still try to project a wholesome image—that's why we never see string bikinis or microminis on the stage.

As pageants eventually moved off the beach into indoor venues, contestants found they needed a complete competition wardrobe. No longer would just a swimsuit with heels do. Many contests evolved into multiple-day events, providing participants with many opportunities to make a positive impression on the judges—their fashion choices spoke volumes. Coordination was key and appropriate outfits for every occasion were a must. A contestant needed a traveling suit, complete with hat and gloves, for arrival. She needed interview suits, casual dresses, and outfits for preliminary competition nights—each carefully thought out and accessorized. She needed the right shoes for each ensemble. And she needed to select jewelry that was subtle, and never ostentatious. At the same time, contestants strove to make individual statements about their personal style within the boundaries

HOW TO COMPETE
IN AN EVENING GOWN

It's tougher than you might think. In 1960, Jacque Mercer, Miss America 1949, gave evening-wear advice in her book, *How to Win a Beauty Contest*:

The evening gown for competition should be floor length. A long dress gives the illusion of height and flows gracefully as you walk. The dress should be full-skirted in a debutante mood, never slinky. Choose a dress of simple lines with a minimum of trim: the judges want to see you, not the dress.

Gloves should always be worn with gowns during competition. The rule is, "the lower the neckline, the longer the glove." So, full-length gloves, crushed slightly at wrist, should be worn with strapless gowns, shorty gloves with the more covered up dress.

Most contestants wear white gowns, but a color, if selected carefully, can help the judges identify you more easily and set you off from the other contestants. However, it is wise to avoid the purples and lavender shades. Color psychologists have proven that the majority of men do not like colors from the purple family. Never wear black; it is too sophisticated and conceals the figure. The following are suggested colors to blend with your particular hair type.

Platinum blonde—jade green, lemon yellow
Honey blonde—sky blues, sea greens
Light brown—turquoise or aqua shades and corals
Brunette—fuchsia pinks and reds
Redhead—turquoise, forest greens, golden yellows
No gaudy prints or stripes, please. The stiffer fabrics, such as taffeta, organdy, brocade, or faille, usually flow better with the movement of the body. However, there is nothing more effective on stage than the shimmer of a well-cut satin or the floating look of cleverly draped chiffon.

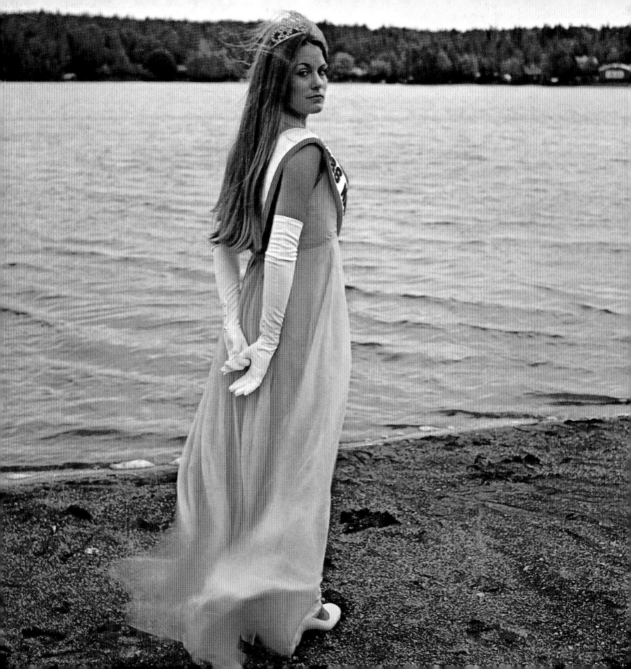

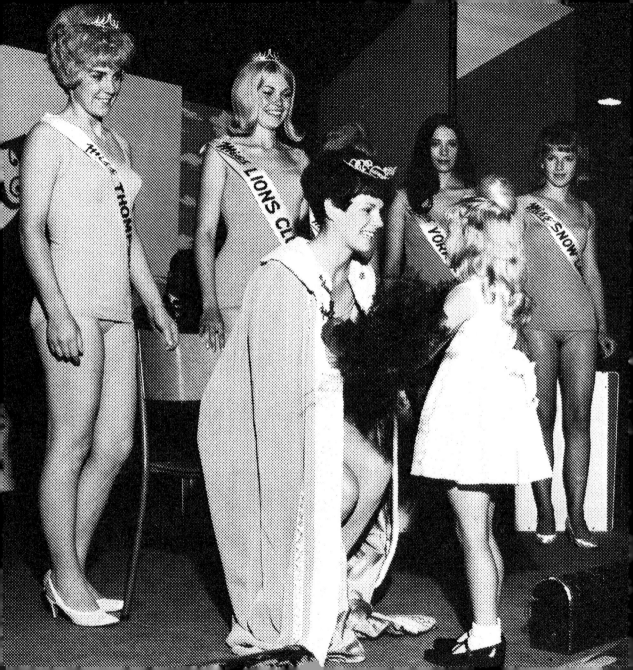

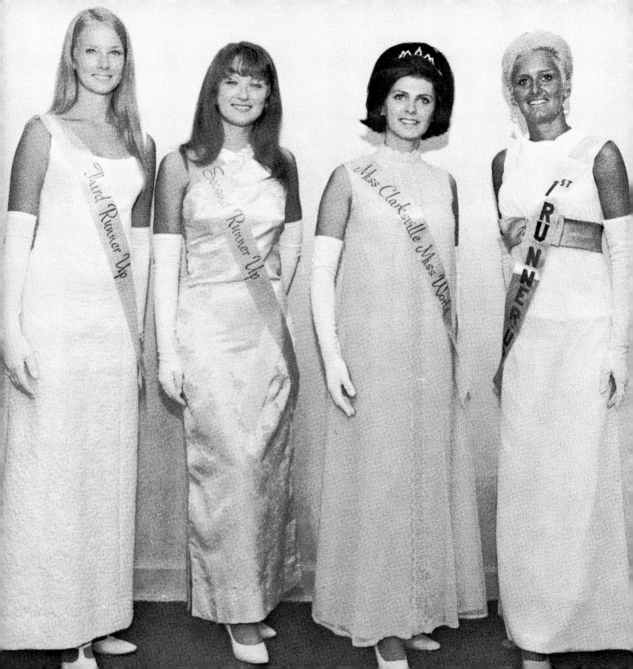

of current-day fashion. These expectations hold true even today. In a nutshell, beauty queens have to choose not only fashions that both mothers would approve and little girls would adore, but also styles that reflect the constantly changing fashion scene. Challenging? Yes. But if anyone can do it, a beauty queen can.

And nowhere is the fashion of the day more apparent than in the evening-gown competition. In the 1920s, the flapper style was all the rage. Contestants chose boyish silhouettes, shorter hems, and bobbed haircuts—fashions both liberating and shocking. The gowns of the 1930s and 1940s featured few flounces and little extravagance, reflecting current fashion and the economics of the times. Pageant contestants aimed for an innocent look with a touch of sophistication. The 1950s ushered in the era of the debutante-style gown, with yard upon yard of shimmering satin, layers of tulle, and gloves up to there. Subtle pearls. Simple coifs. In a word, elegance. Empire waists debuted in the 1960s, and the 1970s floated by on clouds of chiffon. Hair was loosened up to show more natural waves. Beads made a sparkling comeback, leading straight into the over-the-top gowns of the 1980s—which boasted sequins, sequins, and more sequins at every turn. And, to the delight of many a pageant fan, big hair returned. The 1990s and 2000s took a turn toward more individual fashion statements, and gowns now more closely reflect personal style.

While adapting to popular trends, contestants have always made their individual fashion choices an integral part of their presentation. The picture of poise and grace (with the help of makeup, curling irons, blow-dryers, hair gel, wardrobe items, and proper accessories), a beauty queen always radiates style.

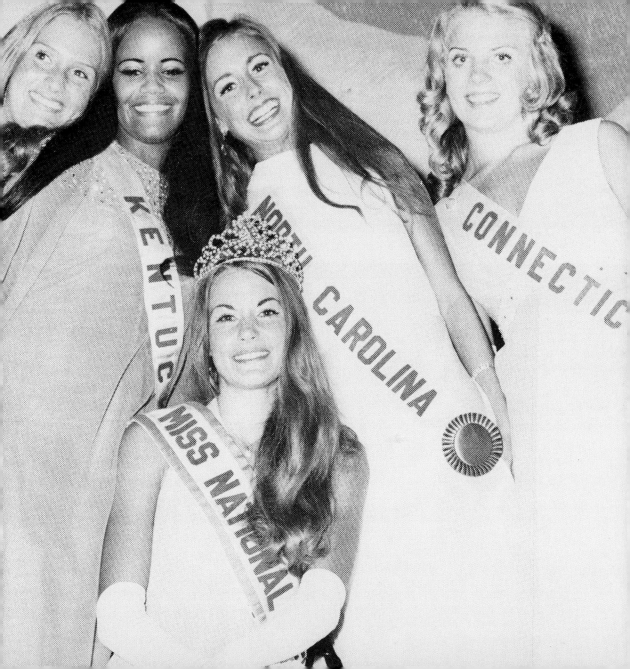

WALK THE WALK

Beauty queens don't walk; they glide. It looks impossible, but with a little practice and some advice from *Becoming a Beauty Queen* by Barbara Peterson Burwell (Miss USA 1976) and her sister Polly Peterson Bowles (Miss Minnesota-USA), we all can glide like a queen. First, think like a queen. Think grace. Think poise. Think elegance. And then, when you're ready, walk on the balls of your feet. It's not a tiptoe; it's more about having your weight forward when you walk. Keep your hips facing straight forward and your head still. Let your arms swing naturally. Move slowly, but with purpose. Place one foot directly in front of the other, as if you are on a tightrope. Smile.

When it's time to pose, stand tall. Imagine you're standing on the face of a clock. Place your back foot at a slight angle, toes pointing toward 10:00, and bring your front heel to rest against the arch of your back foot, toes pointing toward 2:00. Relax your arms and let them hang naturally at your sides. Smile.

And where would we be without the pivot? Start with your left foot pointing toward 10:00, right pointing toward 2:00. Step forward with your left, and then bring your right foot forward, past the left, toes pointing toward 10:00. Rise up slightly on your toes, turn 180 degrees to the left, lower your feet and there you go—you've made half a turn. Repeat and you've done a perfect 360 pivot. Small sigh of relief. Big smile.

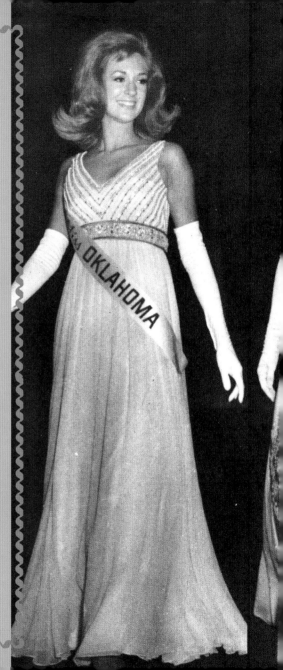

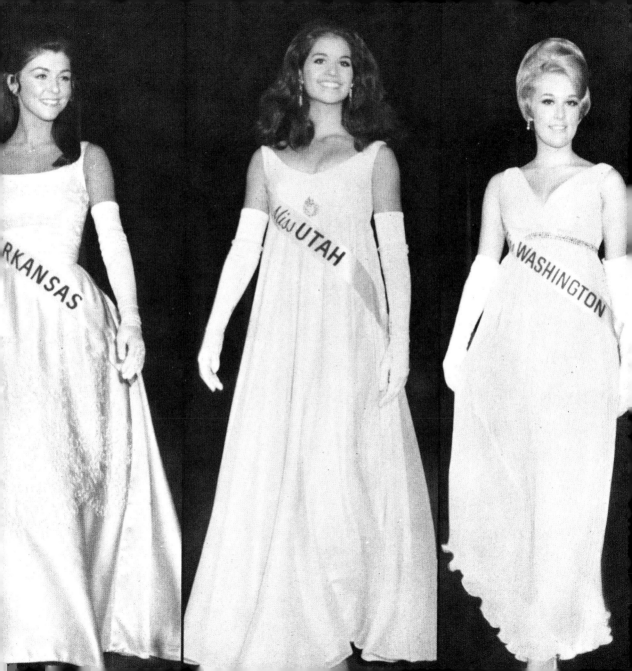

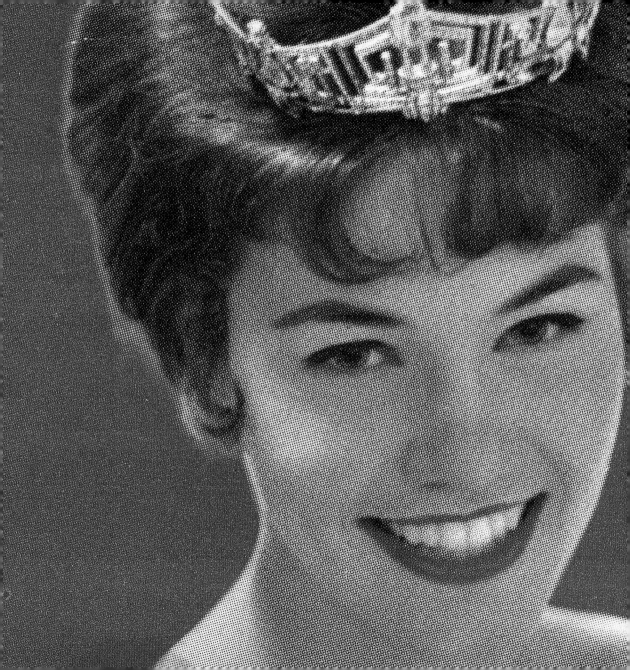

HOW TO SMILE

In Jacque Mercer's *How to Win a Beauty Contest,* the fundamentals of smiling are explained in detail:

The biggest mistake most girls make is in smiling only with their mouths. A smile doesn't start in your mouth; a smile starts in your eyes. It may start in your mind even before that, then it crawls down over your cheeks and, last of all, comes out on your mouth. There are a few simple tricks that will help you smile more easily on all occasions.

The first is to practice smiling when you don't want to. If you are walking down the street, make a game of smiling at lampposts or at every mailbox you see. Practice your smile at home in front of a mirror until you can feel it starting in your eyes and creeping downward. Try not to show your bottom teeth; they're for eating, not display.

A common fault of many girls is that they feel they have to smile all the time. You don't, you know. In fact, many girls look their prettiest when their faces are in repose, or wearing a pleasant closed-mouth expression. In fact, there are four kinds of smiles: (1) smiling just with your eyes, (2) smiling with your lips closed like the Mona Lisa, (3) a soft, gentle smile that shows some teeth but not all of them, (4) a great broad grin. Practice at home until you can turn on and off each of the four smiles at will.

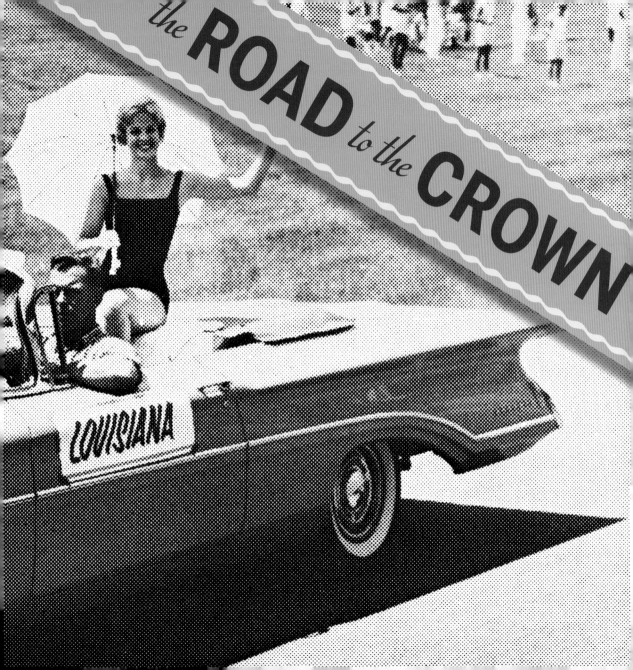

the **ROAD** to the **CROWN**

LOUISIANA

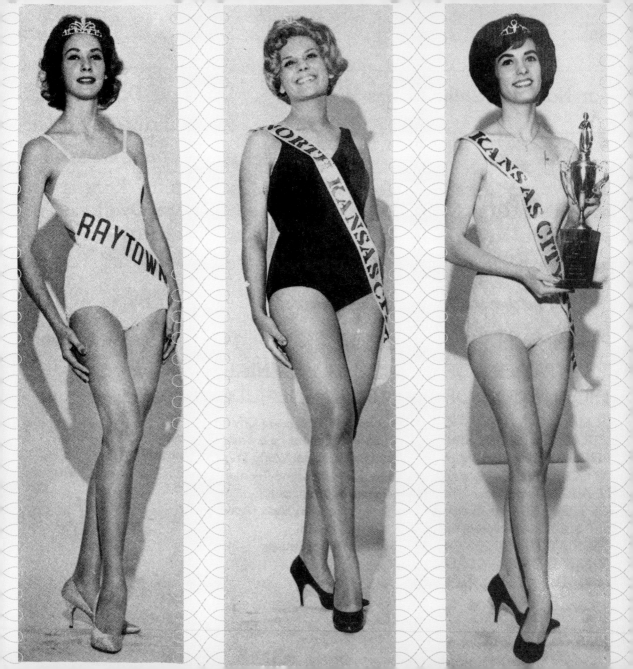

The journey to a major title is long and arduous—it takes much more than a flattering swimsuit and an elegant evening gown to win a beauty pageant. Determination, perseverance, hard work, and a positive attitude are all essential. From local pageants held in high school auditoriums to globally televised extravaganzas with millions watching, contestants prepare for years in order to appear perfectly poised.

While contests in bygone eras required far less advance preparation, today the path to glory has become a serious business—girls can consult with experts on just about every aspect of competition. Before many contestants even apply for their first pageant, they work with coaches, stylists, designers, trainers, and hair and makeup specialists to perfect their swimsuit walk, interview style, and distinctive look, and to boost their confidence and self-esteem. And if the pageant requires a talent competition, she has yet another skill to practice and polish. Along with all this extensive, intensive physical and mental preliminary work, a contestant needs to establish a "platform" to run on, an issue she wants to champion. She can involve herself in education, a charity, a health concern, a racial or domestic issue—a cause that inspires her interest and dedication.

Once a girl feels she's prepared, it's on to the local pageants. Community groups organize these regional shows—where enthusiastic

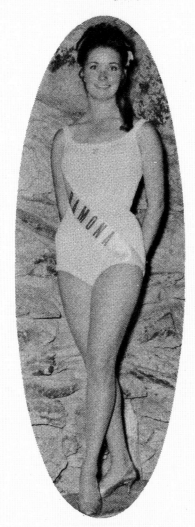

KATIE McGOWAN
Ramona
Merchants

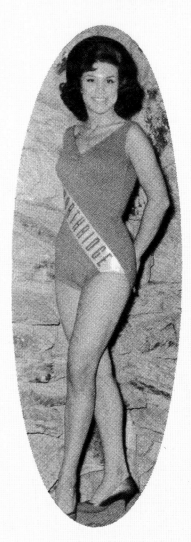

PATTY LORE
Palm Desert
Chamber of Commerce
Country Club Lions

LAUREEN UNDERHILL
Northridge
Sea Fashions of California

SHERYL SMITH
Richmond
Bay Area Pageants

TANJA PETERSON
Palm Springs
Miss Palm Springs Pageant

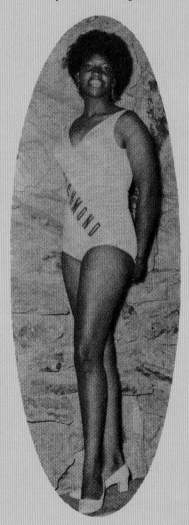

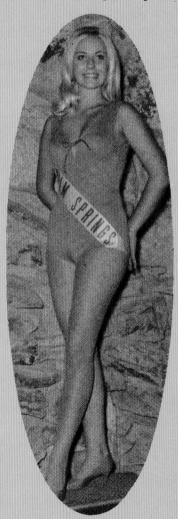

INGRID deNIJS
Newport Beach
Hair Hunters Salon

volunteers coordinate everything from choreography to ticket sales. Local businesses often sponsor girls, covering pageant fees, wardrobe, and traveling expenses. And while local pageants are on a much smaller scale than nationally televised events, the level of competition can be just as intense. Giving everything they have to give, at every level of competition, is the only way contestants stand a chance of walking away with the title.

These affairs provide a chance for local girls to shine in the spotlight—and hopefully to bring glory to their hometown as the winner moves on to larger competitions.

The winners of these small pageants will advance to the next level in a pageant organization. But when a contestant doesn't win, she often reenters at the local level to try her luck again. Contestants view each pageant as a learning opportunity and a chance to further perfect their skills—to work out the kinks and polish their presentation. Input from the judges and other pageant officials is invaluable—a hairstyle change, a wardrobe rethink, or another talent choice could make all the difference the next time. And even if the crown is not in the cards for them on a particular evening, contestants do their best to keep a positive outlook about the experience, using each event as a stepping-stone toward a successful pageant career.

For the lucky winner, the public spotlight beckons. The new beauty queen, at any pageant level, is a sought-after personality. With her sash and tiara, she adds a splash of glitz to local events and brings

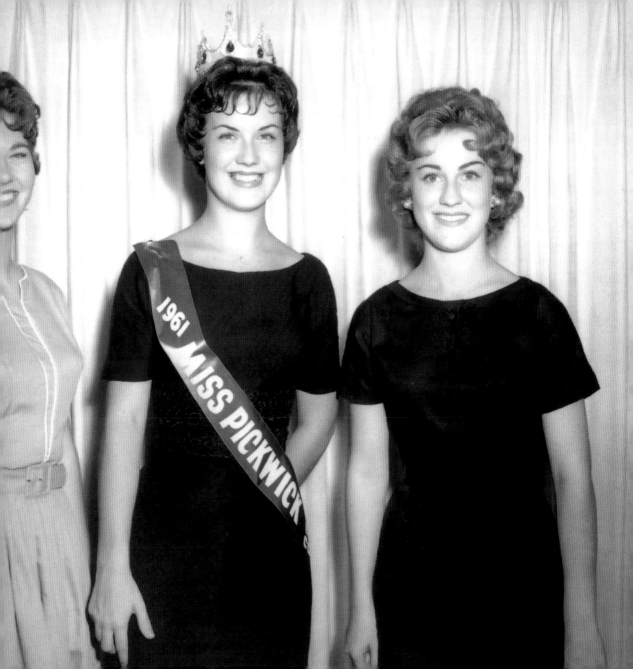

36-24-36-17-5-28...

Pageant judging has always been based on a grading system—each portion of the competition, usually swimsuit, evening gown, interview, and talent, is allotted a certain number of points. But the very first beauty pageants had a far more specific grading system. In 1923, the Miss America pageant used the following criteria to choose its queen:

Construction of head: 15 points
Hair: 5 points
Eyes: 10 points
Nose: 5 points
Mouth: 5 points
Facial expression: 10 points
Arms: 10 points
Hands: 10 points
Torso: 10 points
Legs: 10 points
Grace of bearing: 10 points

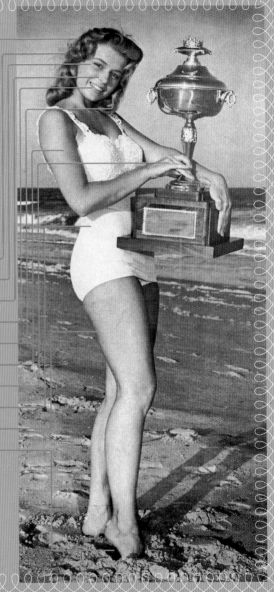

ROSE QUEEN

TROUT FESTIVAL FISHING

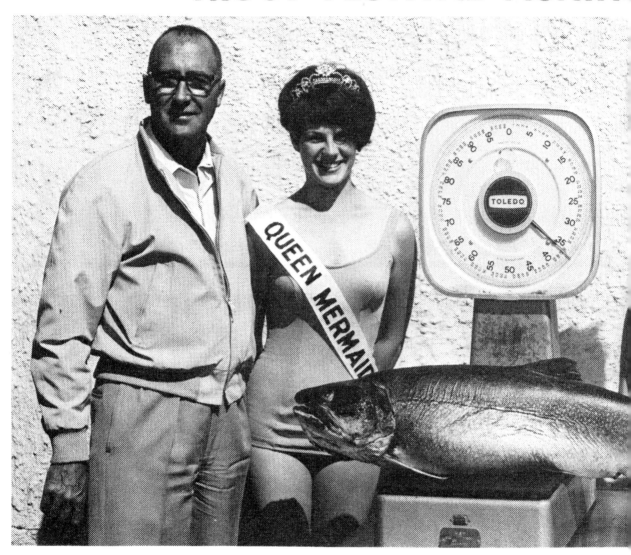

Ernie Leafloor, Brenda Brown, Lucille Beaudette and Wen
prize winning Trout hooked in Lake Athapapuskow.

EVENTS

aull pose with the 1958 36 lb.

renown to her sponsors. She is Miss Somebody and she takes the responsibilities that go along with her title very seriously. But even while adhering to her busy schedule of public appearances, she begins preparing for the possibility of yet another win. Each success takes her another step up the ladder to larger and larger pageants. More competition, more rehearsals, more obstacles to overcome. More anxiety, more pressure, more at stake. It can take years of competing to make it to the national and international competition level. But, as many participants say, the thrill of competing, and the opportunity to travel to new places, to meet like-minded people, to build confidence, and to challenge themselves is worth every defeat. And making it into the top ten or final five, or possibly even wearing the crown home, is an achievement of a lifetime.

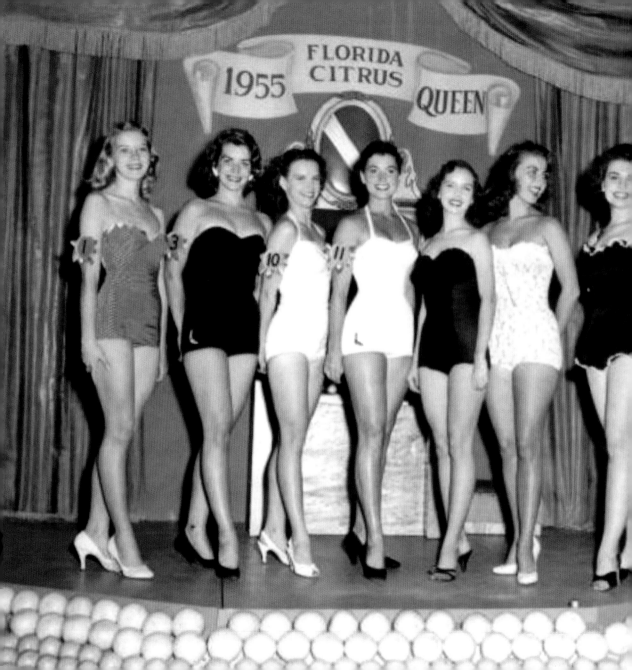

SAMPLE QUESTIONS

The interview. It's a contestant's one chance to impress the judges with her intelligence, wit, charm, sense of humor, poise, composure, social conscious-ness, personal views, political ideologies, and awareness of history and current events. Pressure? You bet. Contestants prepare well in advance for any question that might be thrown their way, spending many hours working with sample ques-tions, perfecting their answers, and honing their interview style. *The Crowning Touch, Preparing for Beauty Pageant Competition,* offers a comprehensive list of potential queries, including the following:

What constitutes real beauty?

Who do you admire most in life and why?

What kind of person would you describe yourself as?

If you could contribute one thing to the world, what would it be?

As a child, what was your favorite game and why?

What is your most treasured memory?

Socrates said, "Know thyself." Name your best quality. Name your worst.

If you could change one thing in our judicial system, what would it be?

What do you think was the most important discovery during the past quarter century?

What woman in public life do you think the most of and why?

Do you feel that pageants sexually exploit women?

Do you believe in love at first sight?

What do you think it's going to take this country to elect a woman president?

1970 Rose Festival

JUNE 8th thru 14th
*CITY OF ROSES
JACKSON, MICH.

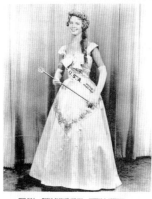

"Miss World" Beauty Pageant

"THE CHAMPIONSHIP OF THE WORLD"

UNITED STATES HEADQUARTERS ALFRED PATRICELLI
 UNITED STATES DIRECTOR

38 FAIRFIELD AVE., ROOM 205, BRIDGEPORT, CONN., U.S.A.

MISS U.S.A. — WORLD PAGEANT 1963-1964 — MICHELE B. METRINKO

Official Preliminary Programme
to
Miss Missouri - - - Miss Kansas
1964 World Beauty Pageant

miss su

national headquarters
TOWN 'N COUNTRY LODGE

produced by
MYRTLE BEACH JAYCEES

9TH A

GREATER

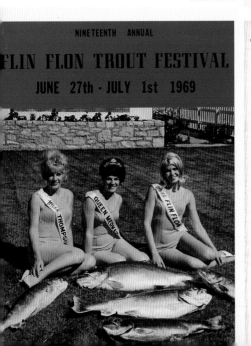

NINETEENTH ANNUAL

FLIN FLON TROUT FESTIVAL

JUNE 27th - JULY 1st 1969

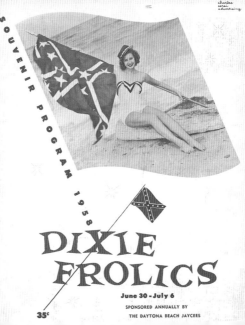

SOUVENIR PROGRAM 1958

DIXIE
FROLICS

June 30 - July 6

SPONSORED ANNUALLY BY
THE DAYTONA BEACH JAYCEES

35¢

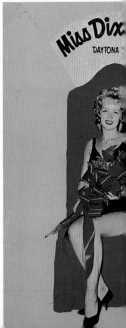

Miss Dix
DAYTONA

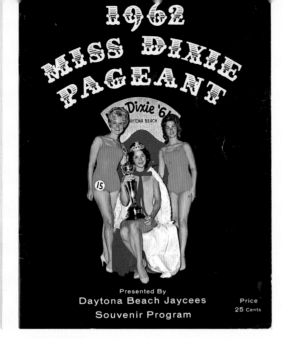

1962
MISS DIXIE
PAGEANT

Dixie '6
DAYTONA BEACH

15

Presented By

Daytona Beach Jaycees
Souvenir Program

Price
25 Cents

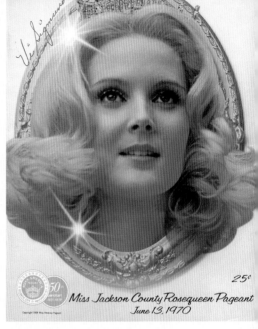

50

Miss Jackson County Rosequeen Pageant
June 13, 1970

25¢

SOUVENIR PROGRAM

DIXIE
FROLICS
1961

PRESENTED BY
DAYTONA BEACH JAYCEES

PRICE 25 CENTS

★ ★ ★ ★ ★ ★ ★ ★ ★ ★ ★ ★ ★ ★ ★ ★ ★ ★
Miss World-U.S.A. Beauty Pageant
★ ★ ★ ★ ★ ★ ★ ★ ★ ★ ★ ★ ★ ★ ★ ★ ★ ★

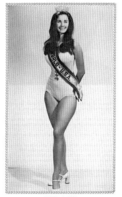

LYNDA CARTER
MISS WORLD – U.S.A. 1972-73

Miss World-U.S.A. Beauty Pageant
SPONSORED BY
BROOME COUNTY CHAMBER OF COMMERCE, INC.
BINGHAMTON, NEW YORK

THURSDAY EVENING
SEPTEMBER 20, 1973

PROGRAM OF THE STATE FINALS
1969
MISS CALIFORNIA-WORLD
BEAUTY PAGEANT

in association with
Miss World-U.S.A. and Miss-World Beauty Pageant
of London, England

MISS CALIFORNIA-WORLD

TELEVISED BY KTTV CHANNEL 11
from
TAHITIAN VILLAGE
13535 Lakewood Blvd.
Downey, Calif.
SATURDAY EVENING, JULY 12

HERE SHE COMES, MISS . . .

The number and variety of pageants and festivals out there are almost impossible to comprehend. Here are just a few that have crowned a queen:

Miss Effingham County Fair Pageant	Sweet Potato Queen
Miss Latina Atlantic Coast	Miss Young International
Queens of New England	Miss Sun Fun
Miss Rice Belt USA	National American Miss
Miss Subways	Miss Sparkle America
Miss Strawberry Pageant	Cherry Blossom Queen
Miss All Nations	Miss Honey Bee
Miss Asia Pacific Quest	Miss Galaxy
Miss Baltic Sea	Miss Asia International
World Queen of Banana	Miss Hickory/Carolina Foothills
Miss Dominion of Canada	Miss India Worldwide
Miss Charming International	Miss Islander
Continental Queen of Coffee	Queen of the World
Miss Earth	Miss Rodeo Oklahoma
Miss Flower Queen	Miss Pope County Fair Queen
Miss Globe	Miss Latin Image
Miss Teen Intercontinental	Miss Florida Citrus Queen
Queen of the Pacific Quest	Miss Azalea Festival
Miss Naciones Unidas	Miss Tennessee Electric
Miss Wonderland	National Donut Queen

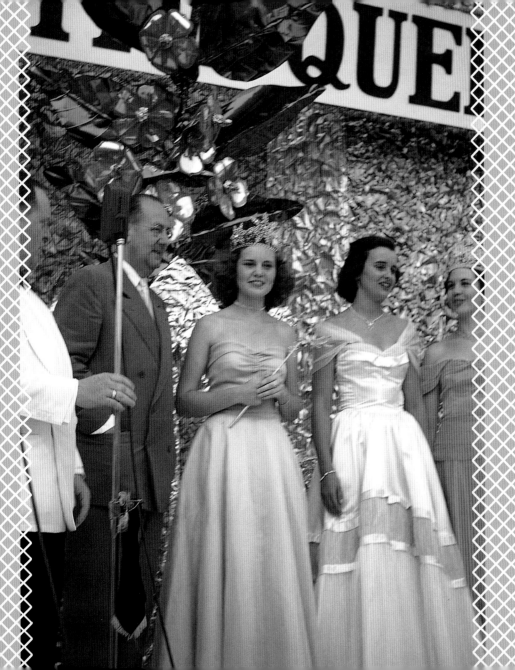

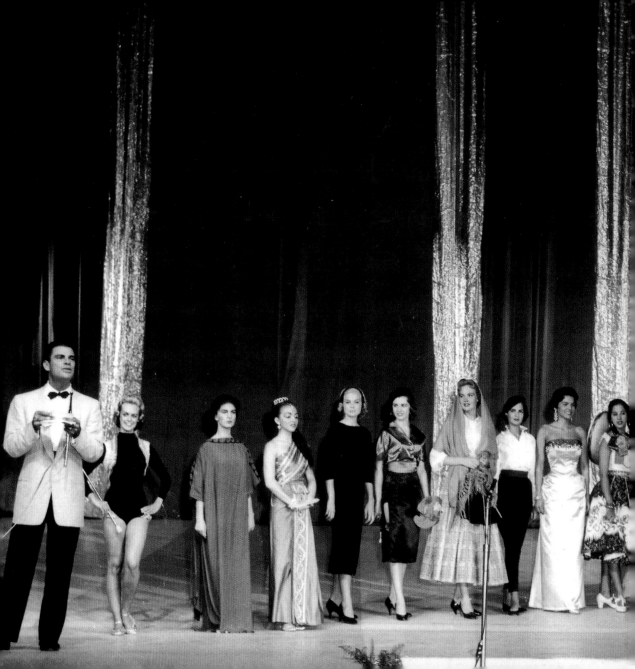

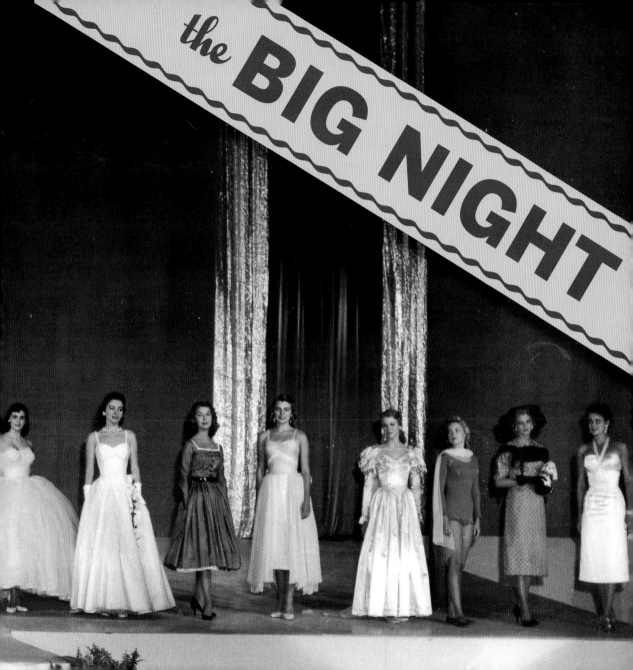

the BIG NIGHT

Cameras flash, evening gowns swirl, dancers in sparkling costumes
light up the stage—a beauty pageant is an evening of excitement,
glamour, and drama from start to finish. But this spectacle is actually
the culmination of weeks of hard work and organization.

From the moment contestants arrive at the pageant, every
moment of their time has been scheduled and planned. Girls, and their
ever-present chaperones, stay together at local hotels, with their
access to the outside world strictly limited. Contestants spend their
time rehearsing with choreographers, staging dance numbers, work-
ing with photographers and coaches, and learning new songs and
new routines to dazzle the audience. In addition to group rehearsals,
each contestant works on her own presentation: talent, if that's a part
of the competition, or interview techniques and practice questions.
During the weeks leading up to the big night, contestants take part
in photo sessions and press interviews, not to mention hours walking
the runway in high heels, hoping that those early mornings and late
nights of preparation will lead to a top spot. And they do this along-
side total strangers, who are competing for the same crown.

The judges also hold initial interviews with the contestants,
a crucial step that lasts just a few minutes. This is a hopeful's most
important opportunity to make a positive impression and stand out

from the crowd. In some pageants, contestants meet each judge one on one, while others have a panel setup. With questions covering topics ranging from personal beliefs to career goals to world politics, a well spoken, provocative, confident answer is what every contestant strives for.

Then it's on to preliminary competitions, held on the nights leading up to the final event. These initial competitions provide a chance for each girl to iron out kinks and get comfortable in front of a large audience in a new arena. Judging takes place on each of these nights, which gives the judges a chance to get to know each contestant. The evening's winners are announced to the audience, but a win doesn't necessarily mean advancing to the semifinals once the competition begins. During these preliminary contests, the judges winnow down the contestant pool into the top group, but those results remain a well-kept secret until pageant night.

Finally, the big night. With nerves stretched to the limit, hair lacquered into place, and Vaseline smoothed onto teeth to keep smiles shining, contestants make their entrance. They glide across the stage, introducing themselves to the audience in the theater and the millions watching from home. "Hi! I'm Miss Alabama!" "Miss New York!" "Miss Texas!" they exclaim, making every moment in the spotlight count. With military precision, the show gets underway.

Early on in the evening the judges narrow the field. The chosen few scream, shriek, cry, give thanks, blow kisses, and hug the girls next them, grateful that their night isn't over yet. As the emcee announces each new semifinalist, the rest continue to smile, praying that they will be called next. But as chances lessen, smiles fade

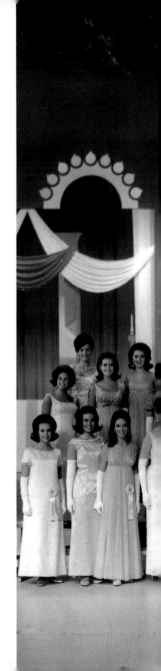

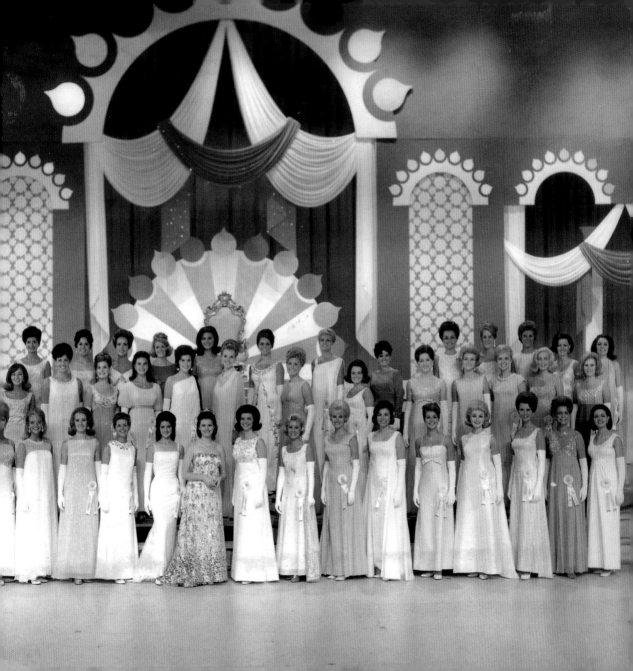

HOW TO PACK FOR A PAGEANT

Contestants agree: when getting ready for a pageant you can never overpack. It's essential to prepare for any emergency or eventuality. And organize, organize, organize. The first step is to coordinate each outfit for every part of competition. Pack shoes, accessories, and outfits together so that everything you need for that outfit is in one place. And don't forget to tuck in the appropriate underwear and stockings. Bring along alternates in case a spill or a tear takes an outfit out of commission. Pack plenty of rehearsal clothes and lots of shoes.

In *Becoming a Beauty Queen,* Barbara Peterson Burwell and Polly Peterson Bowles suggest some of the following. Beauty prep: Include makeup, applicators, cleansers, blow-dryer, hair curlers, styling gel, soap, deodorant, razors, shower cap, toothbrush and toothpaste, mirror, and lotions. How about general maintenance? Make sure to pack Vaseline, vitamins, aspirin, thermometer, antacids, eye drops, sewing kit, safety pins, rubbing alcohol, bandages, sunscreen, insect repellent. Miscellaneous: Don't forget books and magazines, sunglasses, alarm clock, camera, good-luck charms, laundry detergent, hangers, address book, stationery, stamps, umbrella, and extra washcloths.

And Jacque Mercer's *How to Win a Beauty Contest* provides even more suggestions: nose drops, facial masks, candy bars, heating pad, hair pins, cleaning fluid, manicure kit, shoe polish, pillow, hot water bottle, cookies, and a vibrator (for tired muscles).

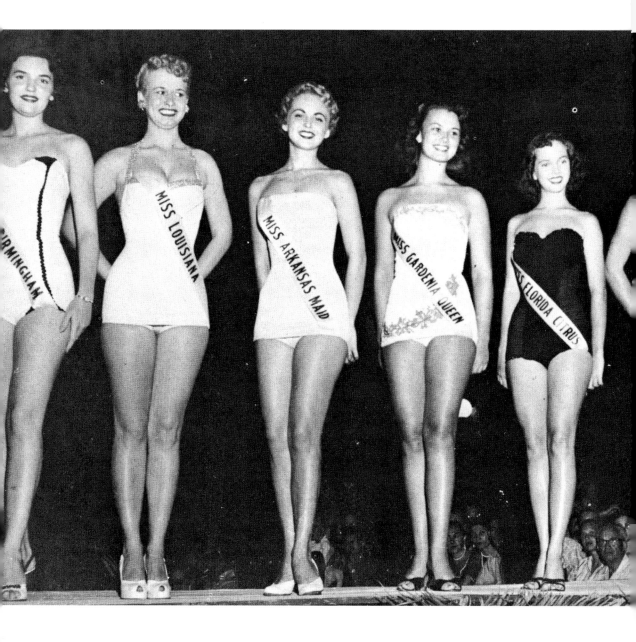

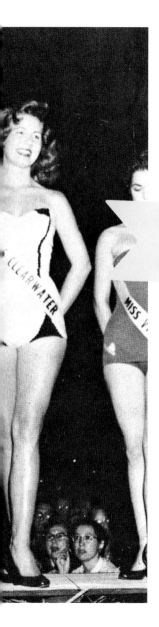

slightly. Finally, the top ten finalists appear together on stage and the contest begins anew.

While each pageant varies in order and content, all feature a swimsuit competition. From its earliest days as the mainstay of beauty pageants, the swimsuit competition has never lost its popularity—and contestants claim that it's the part of the contest that requires the most self-confidence.

In just a swimsuit, high heels, and a bright smile, a girl has nothing to hide behind.

Backstage, contestants do lunges, push-ups, and isometric exercises to pump themselves up, and they add a light application of oil to help their muscle definition pop under the lights. Then they appear onstage to walk the walk and twirl the twirls, their suits kept in place with a quick application of a sticky fixative before they get on stage. In bikinis, one-pieces, halter tops, strapless suits, and tanks, they stroll across the stage with confidence and grace.

Then they hurry backstage for the next change, executed in a few short minutes in tight quarters. Wardrobe changes abound, with costumes for musical numbers, interviews, casual-wear segments, and evening-gown competitions. Each costume choice allows the judges and the viewers to see the contestants in a new light.

The tension mounts during the interviews. What will the question be? What will she say? What would I say? Did she perform well? Did the judges agree with her answer? As the evening progresses,

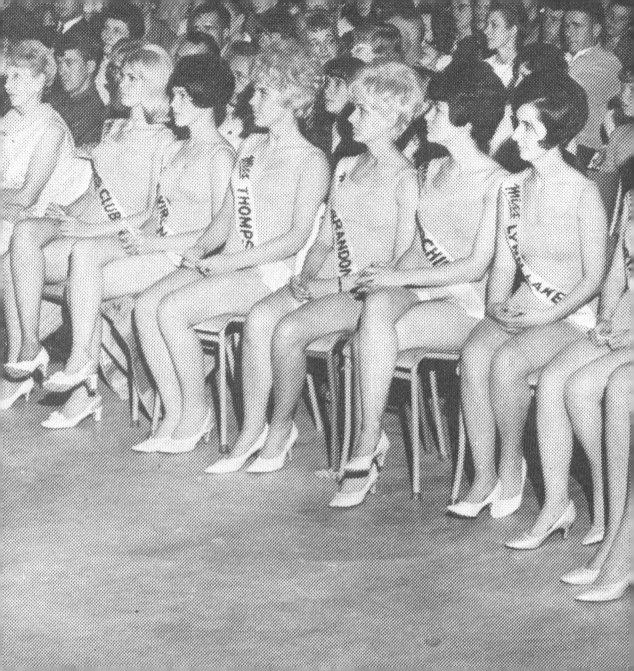

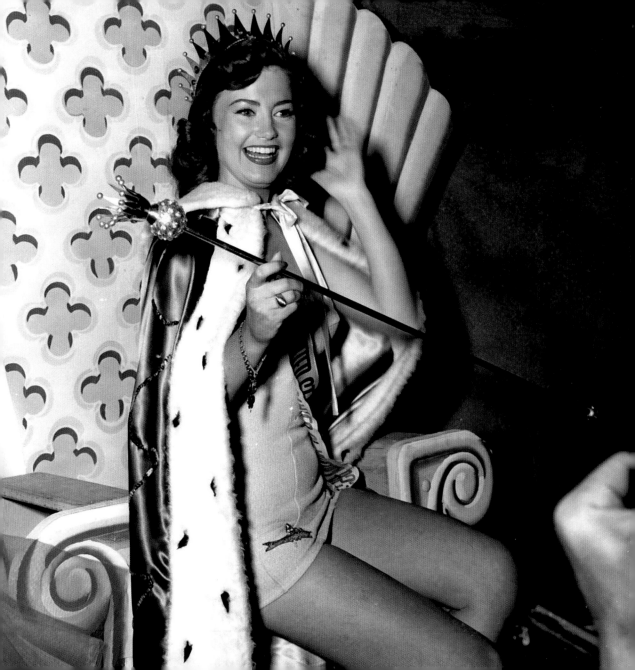

the audience members start singling out favorites, hoping the judges agree with their choices.

Next comes talent. Pianists, singers, dancers—contestants must pull out all the stops and perform to the best of their ability. They get no second chances, no time for stage fright. Each must give the best performance she's capable of at that very moment.

And then the most glamorous portion of the night: the evening-gown competition. Poised, coiffed, and accessorized, each girl takes a walk across the stage. Serenaded by an orchestra, she slowly floats along and the audience floats with her, reveling in the beauty and the sparkle.

But it's quickly back to reality as the field narrows and the emcee calls five more names. The final five step forward. Surprise, disappointment, shock, and elation quickly register. The final queen will soon be crowned.

Another costume change, one more question before the judges, and it's time to name the runners-up. Last year's queen stands by to pass the torch. As the emcee names each runner-up, tension mounts. Finally, just two remain, tightly grasping each other's hands, and the master of ceremonies states that if the winner should not be able to carry out her duties, this woman would take her place. He calls one name and the realization that the remaining contestant is the new queen quickly registers on her face. Tears flow. A crown is placed on her head. She's handed a bouquet of roses, the serenade starts, and she takes her first walk down the runway.

BEYOND
BATON TWIRLING

When it comes to talent, vocalists, pianists, and dramatists seem to be the norm. But some intrepid competitors have provided us with memorable entertainment moments, with performances including the following:

harp, banjo, guitar, drums, organ, and accordion playing (not all by the same contestant)

cartoon and caricature drawing

horseback riding (animal acts were banned after the 1949 Miss America pageant when Miss Montana's horse nearly fell off the stage)

impersonations

magic tricks

comedy sketches

trained pigeons

ice skating

baton twirling both with and without fire (potentially dangerous acts were banned from the Miss America pageant after a flaming baton was accidentally thrown into the orchestra pit)

fashion design

suitcase packing

tractor driving

striptease (the winning Miss America 1959's act—stripping was banned after that)

painting

ventriloquism

trampoline jumping (Miss America 1968's talent)

gymnastics

hula dancing

flamenco dancing

interpretive dancing

jazz dancing

upside-down tap dancing (yes, really)

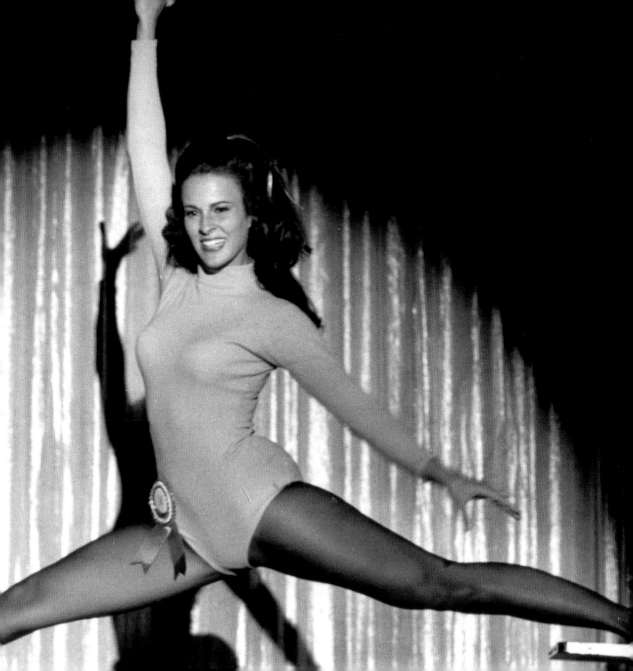

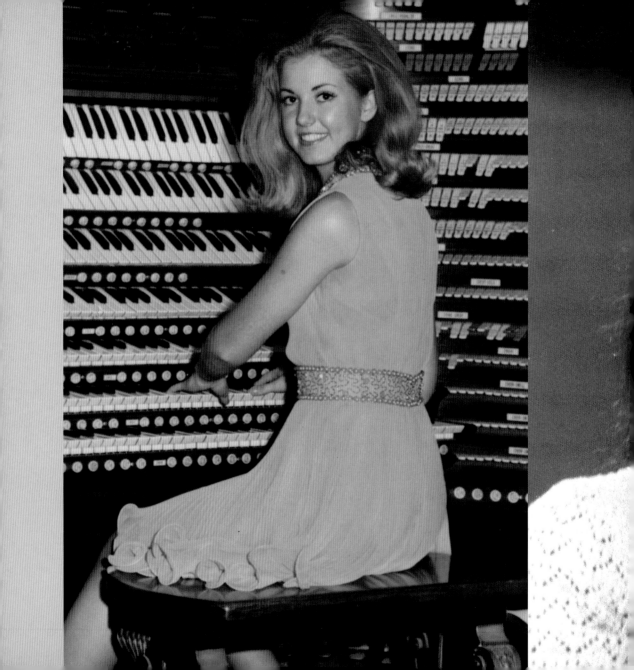

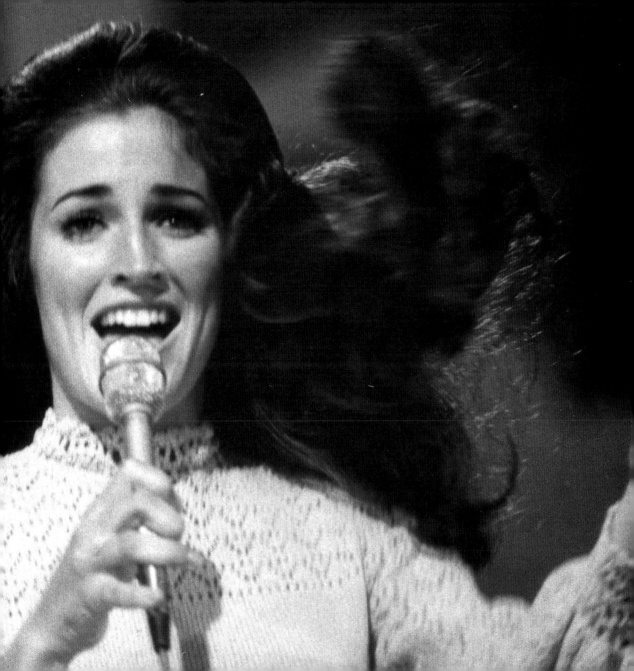

THE JUDGES CAST THEIR VOTES . . .

Every judge in every pageant looks for something different. Judging is highly subjective—and when judging a beauty pageant, each judge's personality and personal preferences affect his or her choices. And what influences each judge can change from day to day. Some judges look for self-confidence and enthusiasm. Others are drawn to relaxed and easygoing contestants. Still others look for thoughtful and well-spoken girls. Some prefer blondes. Others prefer brunettes. Judith Ford, Miss America 1969, was advised to dye her blonde hair brown, since brunettes had won the crown for the previous ten years. But she followed her instinct, stuck to her natural color, and won, breaking the decade-long brunette stronghold.

To help judges in the formidable task of selecting the best contestant from a field of worthy individuals, pageants put forth some general guidelines, like these from Miss USA, as noted in *Becoming a Beauty Queen*:

1. Do not be influenced by applause, demonstrations, or political considerations.

2. There may be a tendency to vote for a contestant because she is of the same ethnic or general background as you, or from your state. Please do not let these factors influence your decision.

3. A beautiful woman should be considered on the basis of her total beauty, not only one particular feature.

4. Judging is based on beauty of face, beauty of figure, poise, and personality. Poise is an essential of beauty.

5. A contestant's grace, or lack of it, in walking, should be carefully observed. Her movements, head, arms, and legs should be noted.

6. Miss USA should posses a high degree of intelligence.

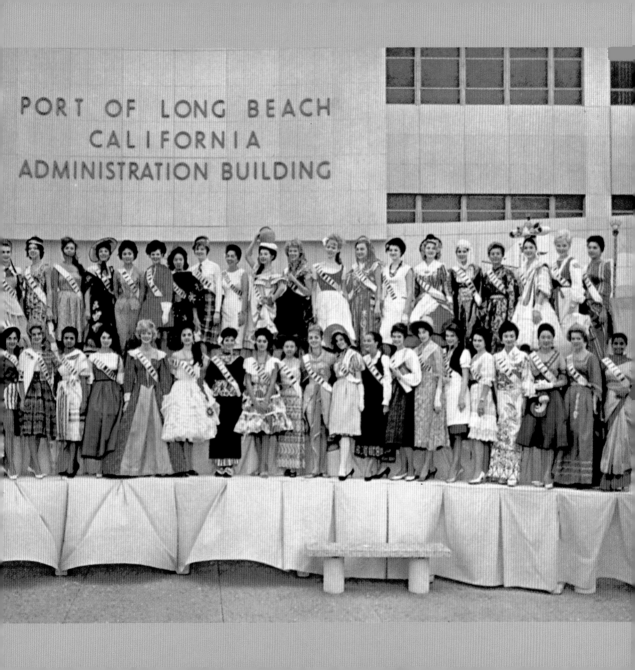

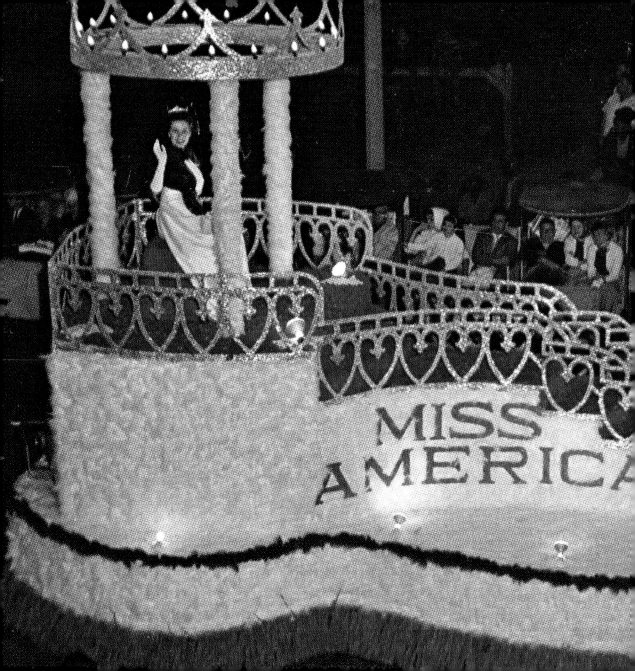

THERE SHE GOES...

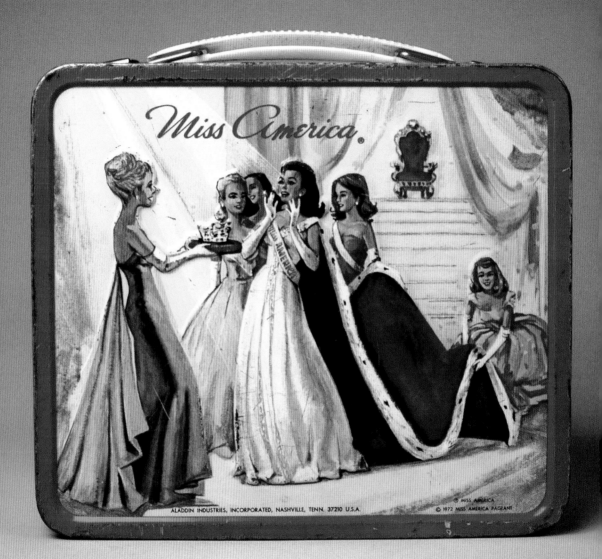

Miss America

ALADDIN INDUSTRIES, INCORPORATED, NASHVILLE, TENN. 37210 U.S.A.

© MISS AMERICA
© 1972 MISS AMERICA PAGEANT

After she gives her final wave from the runway, after she wipes the
last tear from her face, the newly crowned queen's life is completely
transformed. She is now the face of a prestigious organization. Win-
ners often receive a glamorous new wardrobe, a car, scholarship
funds, jewelry, deluxe accommodations for the year, and personal
appearance fees, not to mention limitless media exposure. It will be a
year unlike anything she has ever imagined.

But these elaborate prizes and perks come with a round-the-
clock job. She will spend her reign making public appearances and
doing press conferences, photo shoots, and interviews. She will
undertake more travel and hard work than she's ever dreamed of. In
the ensuing year, there will be no such thing as a typical day. A reign-
ing queen might appear in two or three different cities by the time
she hits her hotel room for the evening. She may grace the cover of a
national magazine, chat on a TV show, act as the keynote speaker at a
function, and appear in a parade—sometimes all in the same day. She
will meet heads of state, corporate leaders, popular entertainers, and
schoolchildren alike. She will appear in advertising campaigns, visit
hospitals, and speak at both elementary schools and colleges—she is
a role model and an inspiration to young people, an example of what is
possible with dedication and hard work.

Along with promoting her pageant and its sponsors, she will speak about her platform, bringing awareness and coverage to the cause she supports. Beauty queens have represented platforms as diverse as racial equality, breast cancer awareness, learning disabilities, and abstinence. Bess Myerson was the first to take a cause to heart—she spent much of her reign speaking on behalf of the Anti-Defamation League. Titleholders have also sold war bonds, visited troops abroad, and represented their countries at international events. They've appeared on cereal boxes, as paper dolls, in comic books, in View-Masters, and as dress-up dolls, and they've been the subject of board games, documentaries, and countless books.

A beauty queen will spend hours on airplanes, traversing the country and often the world. Days on the road and nights in new hotels can take their toll, but hairstylists and makeup artists stand by to make sure she appears as perfect as she did the moment she was crowned. And she's never alone. The pageant provides a chaperone or traveling companion for security, for company, and to help keep the new queen's complicated schedule running smoothly. Part mom, part social secretary, many chaperones remain close to their beauty queens for years after their reign.

It is a year of excitement and opportunity. Of growth and character building. An experience unlike anything the rest of us can imagine.

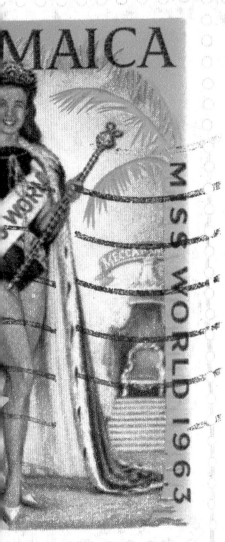
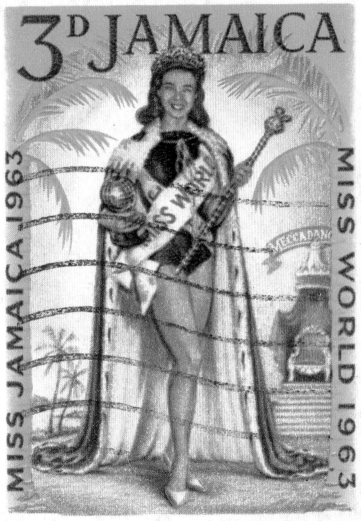

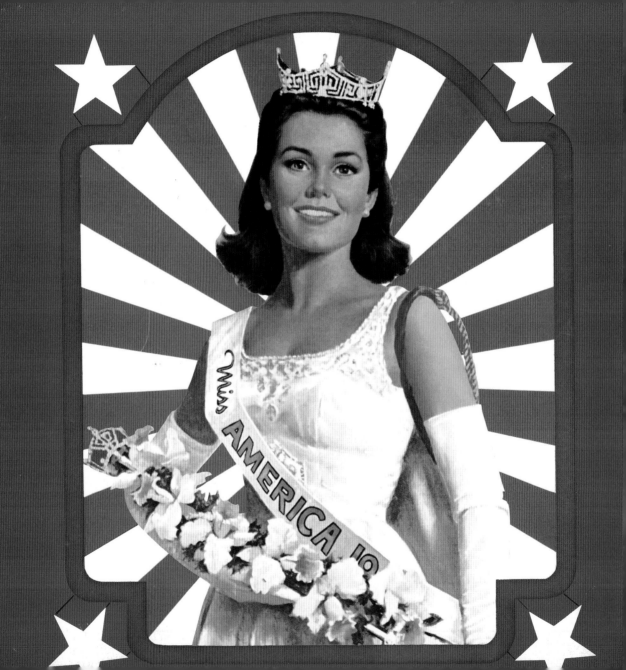

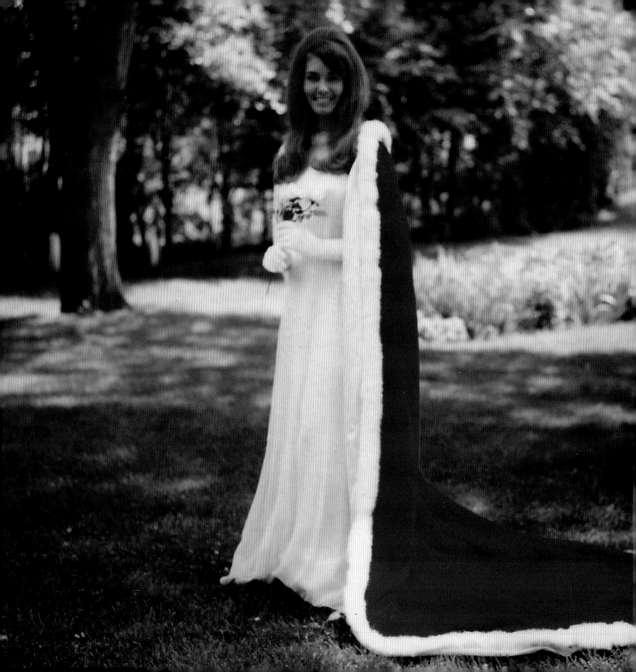

But in a moment it's over. A new queen is crowned and suddenly it's someone else's turn. To be Miss America one minute and then a past winner the next is to experience a tremendous change. It's back to the real world—but a world very different than it was before. The challenges and experiences of each reign have changed every titleholder. Whether starting a new career with connections she's made, going back to school with renewed dedication, or continuing to promote her personal cause, she holds on to the recognition forever. Whatever she does next, her reign as beauty queen will always be a part of our collective history.

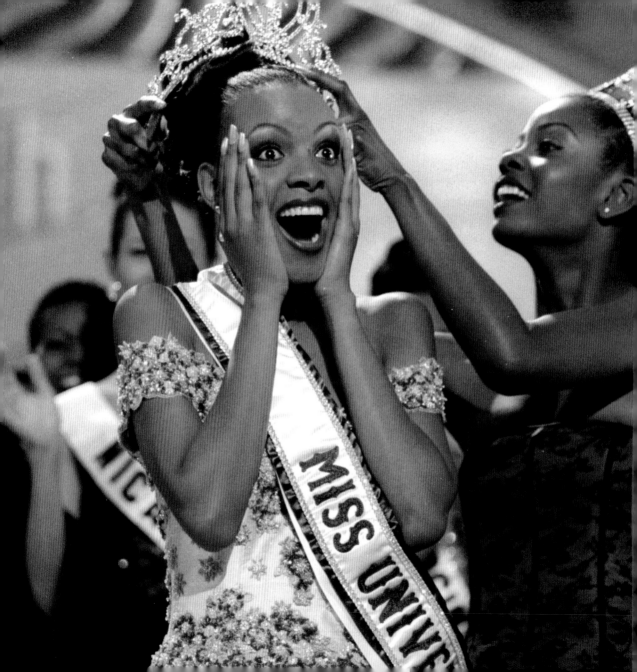

The Girls Behind the Smiles

Page 2 Miss America contestants, 1947. **Page 5** Cathy Whitesell, winner of Poise and Appearance trophy, Montgomery County Junior Miss 1966. **Page 8** Elizabeth A. Muto, Miss Nevada 2004, Miss America Pageant. **Page 9** Tiffany Jenkins, Miss Maryland 2004, Miss America Pageant. **Pages 10–11** Miss USA and Universe contestants, 1957. **Page 14** Lisa Valkert, Miss Vermont 1978, Miss America Pageant. **Page 15** Miss America contestant parade. **Pages 16–17** Lynda Mead, Miss America 1960. **Page 18** Lee Meriwether, Miss America 1955. **Pages 22–23** Carol Ivey, Maine Potato Blossom Queen 1960. **Page 26** Kathy Lynn Baumann, Miss Ohio 1969, Miss America Pageant. **Page 27** Linda Marie Trybus, Miss New York 1969, Miss America Pageant. **Pages 30–31** Miss America contestants 1923. **Page 32** Margaret Gorman, Miss America 1921. **Page 33** Mary Katherine Campbell, Miss America 1923. **Pages 34–35** Miss Universe contestants, 1958. **Pages 40–41** Miss America preliminary winners, 1957. **Pages 44–45** Montgomery County Junior Miss 1966 contestants. **Pages 46–47** Miss Florida-USA contestants 1961. **Pages 48–49** Lenora Slaughter and Miss America contestants, 1955. **Pages 50–51** Miss Universe contestants, 1966. **Pages 56–57** Cheryl Wadell Feldpausch, Maine Potato Blossom Queen 1958. **Pages 60–61** Maria Fletcher, Miss America 1962, and her court. **Pages 62–63** Miss America contestants 1947. **Page 65** Betty Nightingale, Miss National Teenager 1972. **Pages 68–69** Betty Nightingale, Miss National Teenager 1972, and her court. **Pages 72–73** Nancy Fleming, Miss America 1961. **Page 91** Norma Collins, Maine Potato Blossom Queen 1955. **Pages 92–93** Miss America telecast 1957. **Pages 96–97** Miss America telecast 1967. **Page 104** Jackie Loughery, Miss USA 1952. **Pages 106–107** Rebecca Sue Graham, Miss America contestant 1972. **Page 108** Lois Ann Koth, Miss Iowa 1969, Miss America Pageant. **Page 109** Cindy Lee Sikes, Miss Kansas 1972, Miss America Pageant. **Pages 120–121** Charlene Hope Seifert, Miss America Pageant 1969. **Page 122** Mpule Kwelagobe, Miss Universe 1999. **Page 126** Pam Eldred, Miss America 1970.

Photo Credits

Front cover © 2006 Toni® Silkwave™ Home Perm. **Back cover** © 2006 Miss America Organization. **Page 2** © 2006 Miss America Organization. **Page 5** from the collection of Cathy Whitesell Lutz. **Pages 8–9** © 2006 Miss America Organization. **Pages 10–11** Photograph from 1957 MISS USA® Competition, courtesy of Miss Universe L.P., LLLP. **Pages 14–15** © 2006 Miss America Organization. **Pages 16–17** © 2006 Toni® Silkwave™ Home Perm. **Page 18** from the collection of Lee Meriwether. **Pages 22–23** © 2006 Voscar, the Maine photographer. **Pages 26–27** © 2006 Miss America Organization. **Pages 30–31** © 2006 Miss America Organization. **Pages 32–33** © 2006 Miss America Organization. **Pages 34–35** Photograph from 1958 MISS UNIVERSE® Competition, courtesy of Miss Universe L.P., LLLP. **Page 36** © 2006 Miss America Organization. **Pages 40–41** © 2006 Miss America Organization. **Pages 42–43** from the collection of Donald West/pageantopolis.com. **Pages 44–45** from the collection of Cathy Whitesell Lutz. **Pages 46–47** from the collection of Suzanne Crawford Johnson. **Page 49** © 2006 Miss America Organization. **Pages 50–51** Photograph from 1966 MISS UNIVERSE® Competition, courtesy of Miss Universe L.P., LLLP. **Pages 56–57** © 2006 Voscar, the Maine photographer. **Pages 60–61** © 2006 Miss America Organization. **Pages 62–63** © 2006 Miss America Organization. **Page 65** © 2006 Voscar, the Maine photographer. **Pages 68–69** © 2006 America's National Teenager Scholarship Organization. **Pages 70–71** © 2006 Miss America Organization. **Pages 72–73** © 2006 Toni® Silkwave™ Home Perm. **Pages 76–79** from the collection of Donald West/pageantopolis.com. **Pages 80–81** courtesy of Pickwick Electric Company. **Page 83** from the collection of Trina Robbins. **Pages 88–89** from the collection of Donald West/pageantopolis.com. **Page 91** © 2006 Voscar, the Maine photographer. **Pages 92–93** © 2006 Miss America Organization. **Pages 94–95** © 2006 Miss America Organization. **Pages 96–97** © 2006 Miss America Organization. **Page 104** Photograph from 1952 MISS USA® Competition, courtesy of Miss Universe L.P., LLLP. **Pages 106–107** © 2006 Miss America Organization. **Pages 108–109** © 2006 Miss America Organization. **Pages 114–115** from the collection of Trina Robbins. **Pages 118–119** © 2006 Miss America Organization. **Pages 120–121** © 2006 Miss America Organization. **Page 122** Photograph from 1999 MISS UNIVERSE® Competition, courtesy of Miss Universe L.P., LLLP. **Page 126** © 2006 Miss America Organization. *Any errors of omissions in the above are inadvertant and will be corrected in subsequent editions, provided notification is sent to the publisher.*

Bibliography

Bivans, Ann-Marie. *Miss America: In Pursuit of the Crown*. New York: MasterMedia Limited, 1991.

Burwell, Barbara Peterson, and Polly Peterson Bowles. *Becoming a Beauty Queen*. New York: Prentice Hall Press, 1987.

Deford, Frank. *There She Is: The Life and Times of Miss America*. New York: Viking Press, 1971.

Griffing, Marie Fenton. *How to Be a Beauty Pageant Winner*. New York: Simon and Schuster, 1981.

Mercer, Jacque. *How to Win a Beauty Contest*. Phoenix: Curran Publishing Company, 1960.

Saulino Osborne, Angela. *Miss America: The Dream Lives On: A 75-Year Celebration*. Dallas: Taylor Publishing Company, 1995.

Savage, Candace. *Beauty Queens: A Playful History*. New York: Abbeville Publishing Group, 1998.

Stanley, Anna. *The Crowning Touch*. San Diego: Box of Ideas Publishing, 1989.

Van Dyke, Vonda Kay. *That Girl in Your Mirror*. Westwood, New Jersey: Fleming H. Revell Company, 1966.

Watson, Elwood, and Darcy Martin. *There She Is, Miss America*. New York: Palgrave MacMillan, 2004.

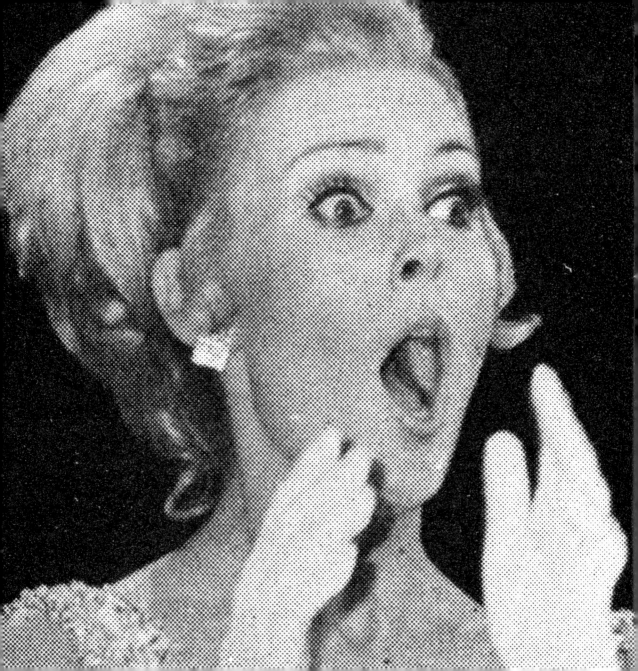

Acknowledgments

There have been many people gracious enough to share their collections and memories with me—without them, *Beauty Queen* wouldn't have been possible.

I drew inspiration from Donald West and his remarkable Web site, Pageantopolis.com. Both the Miss America Organization and the Miss Universe Organization were generous to a fault. Time spent perusing their archives was both fascinating and awe inspiring—folders and files of fabulous fashion—a researcher's dream come true.

Many, many thanks go both to Jodi Davis, for sharing this vision, and to Benjamin Shaykin for making *Beauty Queen* so beautiful. To Trina Robbins, for sharing her wonderful collection, yet again. And to Jon Lichtenstein, who always believed that this was my future.

127

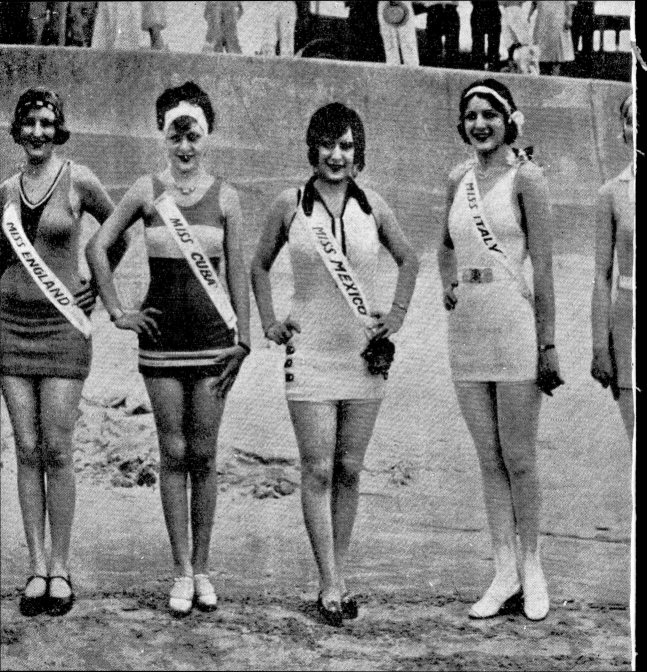

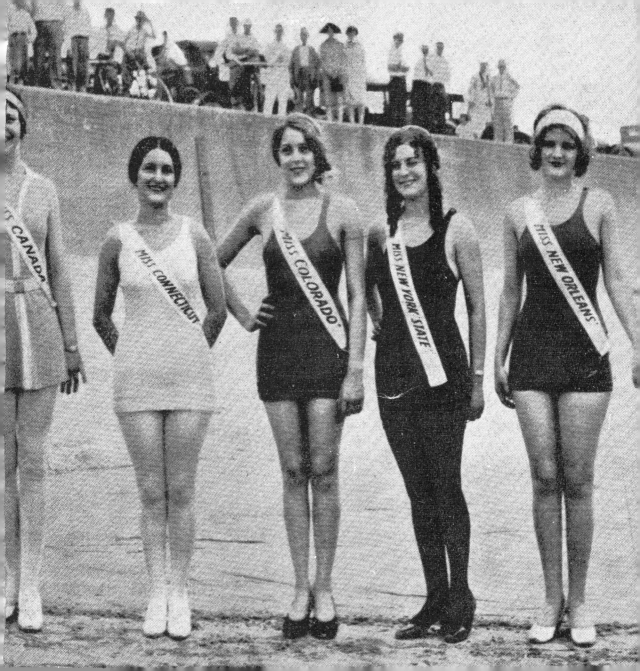

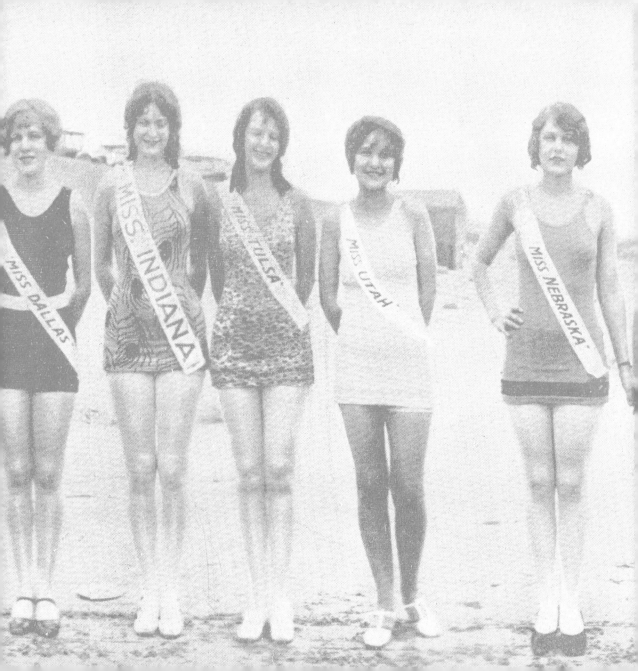